PARALLEL
COMMUNITIES

To Barbara,
Thanks for your
interest in history.

PARALLEL COMMUNITIES

The Underground Railroad in South Jersey

Dennis Rizzo

1/20/09

DENNIS RIZZO

FOREWORD BY JANE DUNHAMN,
UNITED STATES CIVIL RIGHTS COMMISSION

Charleston London

THE
History
PRESS

Published by The History Press
Charleston, SC 29403
www.historypress.net

Cover: Family dressed for a Sunday meeting. Dignity has its place, even in this rural setting. *From the Cross Collection. In Norman Yetman*, Voices From Slavery, *2000.*

First published 2008

Manufactured in the United States

ISBN 978.1.59629.542.1

Library of Congress Cataloging-in-Publication Data

Rizzo, Dennis C.
Parallel communities : the Underground Railroad in South Jersey / Dennis Rizzo.
p. cm.
Includes bibliographical references.
ISBN 978-1-59629-542-1
1. Underground Railroad--New Jersey. 2. African Americans--New Jersey--History. 3.
Slavery--New Jersey--History. 4. New Jersey--History--Colonial period, ca. 1600-1775. 5.
New Jersey--History--1775-1865. 6. New Jersey--History, Local. I. Title.
E450.R59 2008
973.7'115--dc22
 2008038818

Notice: The information in this book is true and complete to the best of our knowledge. It is offered without guarantee on the part of the author or The History Press. The author and The History Press disclaim all liability in connection with the use of this book.

LOUD he sang the Psalm of David,
He a negro and enslaved,
Sang of Israel's victory;
Sang of Zion bright and free

In that hour when night is calmest,
Sang he from the Hebrew Psalmist,
In a voice so sweet and clear,
That I could not choose but hear—

Songs of triumph and ascription,
Such as reached the swarth Egyptian,
When upon the Red-Sea coast
Perished Pharaoh and his host.

And the voice of his devotion,
Filled my soul with strange emotion;
For its tones by turns were glad,
Sweetly solemn, wildly sad.

Paul and Silas in their prison,
Sang of Christ, the Lord arisen;
And an earthquake's arm of might
Broke their dungeon-gates at night.

But, alas! what holy angel
Brings the slave this glad evangel?
And what earthquake's arm of might
Breaks HIS dungeon-gates at night?
—Henry Wadsworth Longfellow

Note: It is interesting to consider that, as this book goes to the publisher, U.S. Senator Barack Obama of Illinois is the selected candidate from the Democratic Party for president of the United States, with a very good chance of winning the election. Two hundred years ago, at the point in which our story is set, he would have been labeled a mulatto and forbidden (in many cases, by law) to vote, own land or hold office. He would have been subject to kidnapping and enslavement at any given moment. He would have had to work as a laborer, deckhand or sharecropper because other, more important occupations were prohibited to him. The Democrats, under whose banner Obama is running, were adamant supporters of slavery, forcing the issue into the American Civil War.

It makes one think.

Contents

Foreword

You are going to find great enjoyment and enrichment in reading this book. For those who know Dennis Rizzo, *Parallel Communities* is a combination of two of his passions: anything historical and the diversity of South Jersey.

From the beginning, New Jersey's role in slave trade, abolition and cultural diversity has meant the clash of new communities with old. Little has been written about the small, rural enclaves that have been so much a part of the lives of people of color in this state. These vibrant communities open up to the reader in this book as the culture of the past comes alive. Whether you read for individual, family or community purpose, the anecdotes and experiences provided in this book will strike a personal chord.

Dennis speaks directly to you, the reader, as if you were seated next to him. His style allows the reader to meander through each piece of history like a story, with humor and tragedy playing equal roles; it takes the reader on a journey of exploration and understanding without becoming dull. His delight in discovering and passing on the history of African American communities in South Jersey is apparent. Every page uncovers the great richness of a people whose culture is as strong today as it was those many years ago.

Jane Dunhamn
Commissioner
Special Advisory Committee
United States Civil Rights Commission

Acknowledgements

O nce, when I was about five years old, I was watching a television show in which kids were being asked where they were from. My father asked me: "Where are you from?" I'm told I hedged and hemmed and hawed and then started crying. "I don't know where I'm from," was my reply. I grew up with an intact family and siblings, but in the military. I was "from" so many places that I didn't know which one to call home.

Researching this book, I came upon story after story of people who, literally, did not know where they were from. There was no intact family tree. There was no recollection of birthplace or extended family. There was the ever-present possibility of being cut.from one family and grafted into another, like experimental horticulture. Your only family was the one in which you resided at the moment. You could be stolen from that family at any time and placed with another, or with none.

For a white guy, raised with an Italian extended family, this effort was an epiphany. The simple, daily horror of familial transience struck me as though I was reading about it for the first time, instead of having studied it in college years ago. I have frequently sought out the histories and the social dialogues, watched the History Channel and PBS presentations and discussed the social implications. But nothing struck me so much as these simple stories of lives forever changed by the whims of fortune and the malevolent transgressions of their fellow men and women, avowed Christians all.

Though not initially about slavery, per se, discussion of the effects and parameters of slavery are essential to understanding these places and their legacy. The communities that this book seeks to illustrate served as extended families. They served as places of familiarity and acceptance. We need to acknowledge that in order to understand why they continued (and continue) to exist long after segregation officially ended. To be sure, some of the amalgamation was economic, but most was cultural and socially structural.

People are gregarious by nature—they seek out their own. It is not odd, but instead totally appropriate, that people on the periphery of society sought out their own and formed communities of support and assistance.

Thanks to Giles Wright for giving me the challenge to think about this topic for a book, and for nudging me further into contact with many local people in each of the communities. Thanks to him, also, for warning me that this tree would not fall with the small axe and short time I had available. The best I could do would be to open the door a notch and let others in to look further.

Thanks to the folks at the Cumberland Historical Society, Greenwich, New Jersey, for their interest and supportive thoughts on the early period of West Jersey. Thanks to the Gloucester Historical Society for assistance in locating documents in their vertical files and discussing the various locations around the county that were, are or could have been fringe communities. Laura Aldrich and Wilber Wright gave me a lot of local lore about Springtown and a lot of encouragement. Joe Laufer, Burlington County historian, shared information he had on Timbuctoo and referred me to several good sources on that all-but-vanished village.

Chris Butler and Reverend Jim Benson gave me real insight into the "community" aspect of Lawnside, New Jersey. In doing so, they cleared many cobwebs from my understanding of the writings and pamphlets on the other towns. Paul Schopp provided details and suggestions that would have taken me years to acquire. Jim Turk, of the Salem County Historical Commission, gave me insight into Marshalltown and events in Salem County. Local residents, many of whose names I failed to get, directed this odd character poking about the weeds and brush to local sites, providing insight as to locations and place names.

The immense resources of the various county library systems made this book possible. Salem County, Cumberland County, Gloucester County, Burlington County and Camden County library system reference departments maintain the story of their places admirably. They shared this as well, without looking askance at the disheveled, haggard person rushing in and out with scanner and laptop in hand. Not enough can be said about the resources maintained by these local organizations.

The Internet. This book would not have been possible in the time available prior to the Internet and the thousands of hours spent, at universities and libraries everywhere, digitizing various collections and cataloguing them. The process of searching out potential and actual documents and resources would have been insurmountable. As before, I give one hundred kudos to those writers of prior times who had to rely on the mails, traveling for

personal interviews and long hours among dusty bookshelves in remote libraries, to develop the details of their books.

I also want to thank, again, Mike Eck of the Mount Holly library. Mike made sure I got my hands on those elusive resources that cannot be gleaned from the Internet. Interlibrary loan is a great thing. Thanks to Pat Krupka for proofing the manuscript and Jane Dunhamn for proofing the philosophy and offering timely criticism.

This book is for my children and their children, that they appreciate the reality that we are all members of the same daily struggle and each of us is no better than the manner in which we regard and treat others. It is also for the long-distant children of the slaves and free blacks and Native Americans, who never gave up working for the betterment of their people. It is for those who belong to multiracial and multicultural families, that they understand this is not a new or unusual phenomenon. It is for those kids I met on Pierce Avenue in Cumberland County, early on, who were unaware that escaped slaves had been hidden right in their area and who thought it was "cool" that they or their families might be descendants of these self-emancipated individuals. It is for future researchers and students, who I encourage to take one or another of the stories and run with it, gather the additional details, find the hidden tales and bring these to light.

Thanks to my wife, Elizabeth, who again put up with the three *A*'s of writing: attitude, angst and anxiety, as well as with literature and litter immeasurable lying about on her dining room table for six months. Thanks to Jed and Bean, our cocker spaniels, for stealing only half my sandwiches this time around as I was rummaging about for a reference or book. I realize this is only their way of telling me I need to lose weight.

It is my humble desire that the reader will gain some insight into his or her own perceptions as a result of this history of small isolated towns. And, that the reader will gain a greater appreciation of the struggles and persistence that gave these people the ability to survive and prosper despite employment bounded by discrimination, assistance constrained by segregation, praise mollified by disdain and benevolence tempered with contempt. Nothing was as important as freedom; nothing mattered if there was no freedom. In this, the members of these small, isolated communities personify the American ideal.

Eastern Shore, Maryland, about 1806–07

*L*ate in the afternoon of a pleasant summer day, two little boys were
playing before the door of their mother's cottage. They were apparently
about six or eight years old, and though their faces wore a dusky hue, their
hearts were gay, and their laugh rang out clear and free.

But as the day wore on they grew weary, and with childhood's first
impulse, sought their mother. She was not in the house. All there was still
and lonely. In one corner stood her bed, covered with a clean blanket, and the
baby's cradle was empty by its side. Grandmother's bed, in another corner
of the room, was made up nicely, and every article of the simple furniture
was in its accustomed place. Where could they all have gone?

Soon the sound of wheels diverted them for a moment from their childish
grief, and looking up the road, they saw a handsome gig approaching. Its
only occupant was a tall dark man, with black and glossy hair, which fell
heavily below his white hat.

He looked earnestly at the little boys as he approached, and marking their
evident distress, he checked his horse, and kindly asked the cause of their sorrow.

"Oh! Mammy's done gone off, and there's nobody to give us our supper,
and we're so hongry."

"Where is your mother?"

"Don't know, sir," replied Levin, "but I reckon she's gone to church."

"Well, don't you want to ride? Jump up here with me, and I'll take you
to your mother. I'm just going to church. Come! quick! What! no clothes but a
shirt? Go in and get a blanket. It will be night soon, and you will be cold."

Away they both ran for a blanket. Levin seized one from his mother's
bed, and in his haste pushed the door against his brother, who was robbing
his grandmother's couch of its covering. The blanket was large, and little
Peter, crying all the while, was repeatedly tripped by its falling under his feet
while he was running to the gig.

The stranger lifted them up, and placing them between his feet, covered them carefully with the blankets, that they might not be cold. He spoke kindly to them, meanwhile, still assuring them that he would soon take them to their mother. Away they went very swiftly, rejoicing in their childish hearts to think how their mother would wonder when she should see them coming.

When the gig stopped again, the sun was just setting. They were at the water side, and before them lay many boats, and vessels of different kinds. They had never seen anything like these before, but they had short time to gratify their childish curiosity; for they were hurried on board a boat, which left the shore immediately.

With the assurance that they should now find their mother, they trusted implicitly, in their new-made friend; who strengthened their confidence in himself by gentle words and timely gifts. Cakes of marvelous sweetness were ever ready for them, if they grew impatient of the length of the journey; and their childish hearts could know no distrust of one whose words and acts were kind.

How long they were on the boat they did not know; nor by what other means they traveled could they afterwards remember, until they reached Versailles, Kentucky. Here their self-constituted guardian, whom they now heard addressed as Kincaid, placed them in a wagon with a colored woman and her child, and conveyed them to Lexington.

This was the first town they had ever seen, and as they were conducted up Main Street, they were filled with wonder and admiration. Kincaid took them to a plain brick house where dwelt one John Fisher, a mason by trade, and proprietor of a large brick yard. After some conversation between the gentlemen, which of course the children did not understand, they were taken out to the kitchen, and presented to Aunt Betty, the cook.

"There, my, boys," said Kincaid, "there is your mother—we've found her at last."

"No! no!" they shrieked, "that's not our mother! O, please, sir! take us back!" With tears and cries they clung to him who had abused their guileless trust, and begged him not to leave them there.

This scene was soon ended by John Fisher himself, who, with a hearty blow on each cheek, bade them "hush! you belong to me now, you little rascals, and I'll have no more of this. There's Aunt Betty, she's your mammy now; and if you behave yourselves, she'll be good to you."

Kincaid soon departed, and they never saw him again. They learned, however, from a white apprentice, who lived in the house, that he received from Mr. Fisher one hundred and fifty-five dollars for Levin, and one hundred and fifty for Peter.[1]

—Kate Pickard, 1856

Chapter 1

Viewing Places in Their Own Time

C ritical to an understanding of what are referred to as small, isolate or fringe communities is to know that racial and ethnic relations and interrelations have been diverse, yet inconstant, throughout the history of the United States. What children are taught about the historical relationships of blacks, whites, Latinos, Native Americans and Asian Americans is often tainted by the most recent political and social agenda. Retelling the stories as they were related during the nineteenth and most of the twentieth centuries gives the student the stereotypical bias and discrimination that were prevalent in those periods. Telling the stories of these communities within a modern context of absolute political correctness results in a loss, or at least a dilution, of the passion and societal upheaval that was all too common in the formation and sustenance of these places.

THE PLAYERS

To begin with, the term "black," as now applied, was also frequently applied through the middle of the nineteenth century. The term "Negro," from the Spanish and referring primarily to academic racial distinctions such as those labeled Caucasian, Oriental, Native American and Negro, was less frequently applied. "Negro" became more commonly used (from this author's reading) in the later nineteenth and early twentieth centuries, as black writers and educators sought to "normalize" the status of the black person in the world anthropological order and counter mainstream academia's search for scientific evidence supporting the natural supremacy of the white race.

More commonly, we see the terms "colored person," "mulatto," "maroon," "mixed-blood" or others being applied by the white political majority and most legislation (and some minority members, as well). Of course, pejorative

terms are quite evident in the various writings of the different periods: nigra, nigger, mammy, coon, picaninny, darky, wench and half-breed. While it would be politic (and proper) to omit all reference to those terms, they are essential to achieving an understanding of the situation within the context of the period and the communities being presented. "Black people," being the term most universally applied in the resources, will be used for the most part (with the small *b* often found in extant literature), with the term "colored" reminding the reader of mixed race and tri-racial members of the communities in discussion.

When looking at isolated communities, however, it is important to note "mulatto," "tri-racial," "colored," etc., as period terms indicating an interaction of races within these communities and elsewhere. Such legal and social terminology, at least through the end of the Civil War, dictated the individual's opportunity and station, defined the application of law and opened or closed doors. It would probably be more appropriate to simply say "people," if the purpose of this discussion was not to address the cross-cultural elements that many believe are new to our society. Indeed, the interrelation of white, black and Native Americans existed from the first encounter of each with the other in the New World and reflects the inherent capacity of individuals to surmount cultural and social obstacles and biases. Samuel Ringgold Ward recalls:

> *My mother was a widow at the time of her marriage with my father and was ten years his senior. To my father she bore three children, all boys, of whom I am the second. Her mother was a woman of light complexion; her grandmother, a mulattress; her great-grandmother, the daughter of an Irishman, named Martin, one of the largest slaveholders in Maryland. My mother was of dark complexion, but straight silk like hair.*[2]

Another important note is that not all blacks in America were slaves. At the same time, some whites and Indians in America were slaves. Slavery took several forms throughout the early years of founding the various colonies, when populations were very small and everyone was involved, side by side, in securing basic survival. In the virgin conditions of the new land, plantations quickly became more expansive, wealth more prevalent and labor needs greater than could be managed with the trickle of immigrants from Europe.

> *Slavery during the colonial era was not a static, unchanging institution. During the early seventeenth century, slavery was far different from what it would later become. Anthony Johnson was one of Virginia's first slaves.*

Viewing Places in Their Own Time

Arriving in 1621, he was put to work on a plantation along the James River, where he took a wife, Mary, and raised at least four children. During the 1630s, Johnson and his family gained their freedom, probably by purchasing their own freedom. Johnson subsequently acquired an estate of 250 acres, which he farmed with the help of white indentured servants and at least one slave. Just as remarkably, Johnson successfully sued in court for the return of a slave, who he claimed had been stolen by two white neighbors.[3]

As Johnson's life suggests, the black experience in seventeenth-century America was extremely complex. Some persons of color were permanently un-free; others, however, were treated like white indentured servants. They were allowed to own property and to marry, and they were freed after a term of service or remittance of their debt. In several cases, black slaves who could prove that they had been baptized successfully sued for their freedom and won on the basis of early religious interpretation of secular law. Other people of color were slave owners themselves, owning black, white and Native American slaves and employing indentured workers.

Theopholus Gould Steward, descendant of one of the families in this discussion, served as chaplain to the Twenty-fifth Regiment of U.S. Regulars (colored) in the Indian Wars and the War with Spain. His comments are relevant; they come from someone whose roots are seeded in the blended family, in the community of free blacks, escaped slaves, Indians, whites and coloreds:

Besides the slaves in the South, there were several thousand free persons of color…Some of these had become quite wealthy and well-educated, forming a distinct class of the population. They were called Creoles in Louisiana, and accorded certain privileges, though laws were carefully enacted to keep alive the distinction between them and the whites. In South Carolina…representatives of their class became slaveholders and were in full accord with the social policy of the country. Their presence became an encouragement to the slave…the free colored man became more and more disliked as the slave became more civilized. [Between 1850 and 1860]…many moved North, establishing communities of their own, and maintaining their belittling prejudices, [stereotypes] and reluctance to interact with and relate to free blacks considered their inferiors.[4]

Within only one or two generations, the heirs of the original European settlers acquired their wealth and land through inheritance, instead of by

working side by side with their servants and employees. This was particularly true in the Southern colonies, where the land, climate and cultivation practices made large-scale production and slave labor cost-effective.[5] Those arriving from Europe with sufficient resources were able to purchase tracts of land already prepared for farming and husbandry. At that point, the white majority (Euro-Americans) used its collective wealth and influence to establish slave status as a just and permanent condition for those of color, presenting a variety of rationalizations whenever questions arose. A systematic exploitation of servants and slaves became necessary to the economics of the colonies, institutionalizing the practice in law and custom to the point where it was taken as a given. Even Quakers held slaves in the early days.[6]

According to Louise Heite:

> *The relationship of English and Anglicized Americans with persons of color took another, related but separate, turn during the seventeenth century as well, as race-based chattel slavery grew quickly out of the old customs of indenture and bondage. The original Black settlers were in fact no more slaves than the common indentured Englishman, but very quickly their color and their different culture branded them, and left them unable to claim the freedom due them under the law. Color prejudice and chattel slavery married, and produced an economic system as firmly bound to human bondage as the Medieval feudalism from which it ultimately derived.*[7]

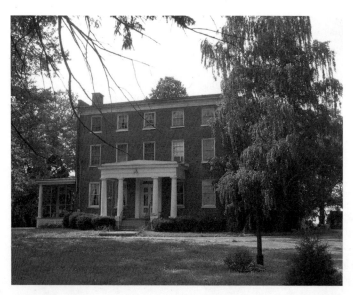

A plantation house on the Salem River. Literally "on the river," this house was only reached by driving on a single-file concrete causeway about six feet wide. Water from the Salem River laps at the sides of the roadway. *Author's photo.*

Viewing Places in Their Own Time

The manner of cultivation and husbandry varied from the Northern section of the colonies (New England) to the Southern section (Maryland to Georgia). The larger plantations possible in those Southern environs made the employment of large workforces economical. The rocky ground and sparse conditions in the North made small, individual farms more profitable and manageable. The seeds of sectional differences were sown by the soil on which the colonies were planted.

A second, equally significant social factor was the belief among white populations that Indians and blacks were a threat to the stability of the community on the basis of natural selection. Though there were many members of the white majority who felt brotherhood with the colored populations, the tradition of supremacy remained firmly entrenched in social, economic and ideological practice. In order to sustain this tradition, it quickly became necessary to establish a legal basis for the belief, since no rational basis existed.

Passages in the Christian Bible were used equally by abolitionists and slaveholders to justify and sanctify their positions. Preachers spoke for and against slavery as a system and in practice. Interrelationships between the races were strongly discouraged, even to the point of death. Quaker missionaries to the New World were actually tried and hanged in Puritan Boston for preaching their brand of Christianity. Tolerance did not arrive with the early colonists.

Very early on, it became ideologically necessary for the white population to disparage, ridicule and suppress the colored populations in order to ease the hypocritical juxtaposition of their own Christian beliefs and suppressive secular practices. Even many abolitionists, while vehement in their passion for ending the institution of slavery, were known to abhor the thought of the races intermingling or marrying.[8]

George Fishman, in his book *The African American Struggle for Freedom and Equality*, notes:

> *An ugly dimension of the free African American condition was ideological vilification, distortion and caricaturing, linked to social degradation and institutional discrimination. This racial transducing served as a rationale for enslavement, re-enslavement, cheap labor, discrimination and divisiveness on racial grounds.—Frequently, slaves would be listed for sale along with cattle, pigs and household belongings.*

As T.G. Steward indicates in his review of conditions and social structure, "there were three very distinct classes of colored persons in the country, to

wit: the slave in the South, the free colored people of the South, and the free colored people of the North."[9] These were divided into subcategories, each with its own pecking order. Slaves were divided into field hands and house slaves. Free Southern blacks had their social class, usually based on color distinction (lighter to darker skinned). The free blacks in the North had distinctions based on religion, difference in place of birth and, as Steward states, "family conceits." As one who grew up in this cauldron of social strata, Steward notes that by the start of the American Civil War it became difficult, if nigh impossible, to develop a social and cultural map of this population that made up four million people in the United States.[10] This social divisiveness left little option for colored people (of all combinations) but to establish their own cultural and social support systems.

Within the slave community this was evidenced by, among other things, building a language and culture hidden from the white majority. This culture carried over the years into the isolated communities at which we are looking. Some excellent work within African American museums (such as at the Smithsonian in Washington, D.C.) provides documentation and substance to the daily lives of the slave in America. Numerous local and state cultural heritage societies (the New Jersey Historical Commission has several presenters on this topic) have preserved much of the African tradition for us to witness firsthand, though not all can be easily related to the slave life. The accuracy of their interpretations may be challenged, but not the exuberance of their delivery.

Among free blacks and other colored persons, the segregated, intact, isolate community became the functional tradition. Native Americans in New Jersey also slipped quietly into interrelated communities, established cross-cultural families and legacies and remain to this day, despite many claims down the years that they all had, long ago, moved West.[11]

Then there were those who were hired to "return" slaves to their masters. The catchers. They came by night and waited for mistakes. They employed spies and covert agents to locate and snare escaped slaves living in the area. They employed the letter of the law (the 1850 Fugitive Slave Act helped immensely) and were determined to acquire their bounty. They were distinct from the kidnappers but were not immune to that means of profit if they required it to pay the bills. George Alberti Jr. and Michael Donehew (Donahue, Donahower) were two noted catchers in the South Jersey area; their names show up regularly in court documents and cases.

Gloucester County Court Records—James Miller vs Fillis—1836
January 27th on the application of Michael Donahower of Philadelphia

Attorney of James Miller Senr. of Sussex County in the State of Delaware, in writing under his hand and seal duly constituted who at the same time produced an affidavit of the said James Miller San properly authenticated, I issued a warrant to arrest Fillis, a woman rather low and Stout chesnut colour aged about thirty five years who is the Slave of and oweth labour and service to the said James Miller Senr in the State of Delaware from which the said Fillis hath fled and made her escape from her said Masters service and labour sometime in the month of November 1832.[12]

THE STAGE: SOUTHERN NEW JERSEY (WEST JERSEY)

Looking at a modern map of New Jersey, one can see the route of Pointer's Auburn Road from near Marshalltown (North of Salem) to its intersection with the King's Highway (the original north–south roadway in West Jersey) and its course to Swedesboro and Woodbury. From Swedesboro, it is a

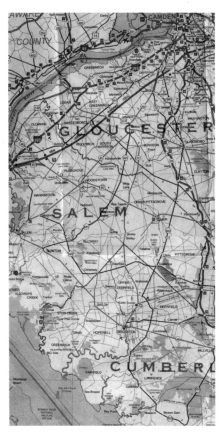

Map of South Jersey. *State of New Jersey, Division of Tourism.*

diversion of less than a mile on Route 322 to the site of the Mount Zion Church on Garwin Road. Traveling on about five or six miles, one passes between Saddlertown and Snow Hill. From Snow Hill to Jacob's Chapel and Evesham Mount is less than five miles. From there to Mount Holly and Timbuctoo is about five or six miles. These are the fringe communities of this discussion. They are also some of the more prominent stations of the western route of the Underground Railroad within New Jersey.

The geographic territory in our discussion is located in what are now the southernmost counties in New Jersey. Following the English acquisition, the division was Cumberland, Salem, Burlington and Gloucester. These now make up Gloucester, Camden, Cumberland, Salem, Burlington Atlantic and Cape May Counties. The towns we will look at are within these boundaries and located mostly within what is known as the coastal plains. Though there are several "mounts" in place names, the highest elevation in this area is a mere 175 feet or so above sea level—no competition to the Rockies.

R.C. Koedel notes:

> *From a low midland of scrub pine and oak, the region slopes toward the marshy inner and outer coastal plains. It is an area bounded on the north by the Pine Barrens, lying between the waters of the Delaware on the west and the Atlantic on the east, and reaching southward in the shape of an inverted*

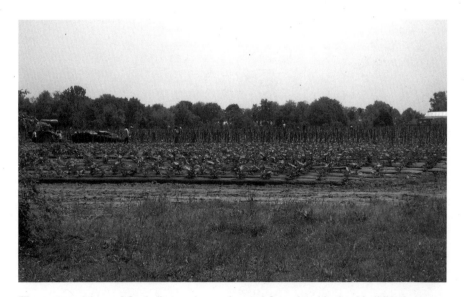

The tomato pickers—Marshalltown. Across the road from the old school building in Marshalltown was a crop of tomatoes being staked by migrant workers. Seasonal work is the mainstay of this area even today. *Author's photo.*

pyramid to a point where the bay and the ocean meet. The present-day counties that South Jersey comprises are Cape May, Cumberland, Salem, Gloucester, Camden, and Atlantic, along with the areas of Burlington and Ocean Counties that border on Pennsauken Creek and the Mullica River.[13]

The population of this area is a mix of early families (English, Dutch, Swedish, Native American and black), late nineteenth-century immigrants (mostly Italian and Polish), latter-day migrant workers (mostly Latino and Caribbean) and day-trippers (mostly casino employees and commuters from Philadelphia). For most of its history (until the 1980s), South Jersey was the isolated "little sister" to North Jersey, with its proximity to New York.[14] It remains distinctly different in culture and pace from its congested northern relations.

Campbell's Soup started its operations in this area (Camden) because of the proximity of large areas of tomato and chicken farming (for soup). RCA-Victor produced the phonograph in Camden for many years, bringing in employees to populate that town. Seabrook Farms (Deerfield) remains one of the largest vegetable-packing operations on the East Coast. Ocean Spray operates a major plant in the area (Bordentown), taking advantage of the area's cranberry production (second only to Massachusetts). Blueberries have been cultivated since early times, and the modern varietals rival those of any other state, including Maine. Many of the current techniques for cultivating blueberries and cranberries were developed and tested in this area (at Whitesbog) in the late nineteenth and early twentieth centuries.

Koedel writes:

In a sense, South Jersey is a historical entity, separate from the rest of the state. Its patterns of social, economic, and cultural development were different from those of the northern counties. The ethnic and religious backgrounds of its colonial settlers were more various. On the other hand, the new Immigration of the late-19th century introduced less national and cultural diversity into South Jersey than it did to northern New Jersey.[15]

Pollution, as in many places in the United States, almost eliminated the coastal watersheds and marshes as habitats. Legislation and strong environmental efforts in the past twenty years have resulted in the return of scarce species and cleaner water. Ospreys and eagles now settle in the coastal plains and hillocks. Otters, muskrats and even beaver have come back along the creeks and streams. Despite population surges, South Jersey counties remain significantly pristine when compared to their northern relatives.

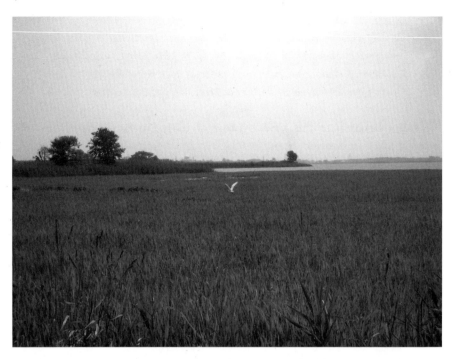

Marshland (tributary of Salem River). After joint efforts by environmentalists and industry, Salem's numerous creeks once again thrive with fish, birds (such as the heron) and wildlife. *Author's photo.*

THE STORY: FREE COMMUNITIES OF COLOR

Despite modern immigration, the small communities in this book have retained a measure of isolation and local identity. In some cases, they are barely recognizable; in others, they remain strong and vibrant. Building these communities took a lot of hard physical, social and organizational work. Their citizens built upon what they had the most of—what is referred to as "human capital," as described in several forms in the social science professions. Anthony Condeluci offers the following explanation:

> *Sociologists refer to friendship as "Social Capital." To the academics, the term "capital" is one that speaks to resources that can advance or promote a profit. They talk about physical capital which refers to things like land or machinery. Economic capital might refer to goods, or services that drive an economy. "Human capital" is often thought of as the people needed to do the work to create the goods or services.*

Viewing Places in Their Own Time

Community building involves creating and sustaining all of these forms of capital. While initial settlers in each location (white, black and other) were isolated farmers or woodcutters, they built bonds with each other based on necessity and survival. These bonds transcended race, culture and (usually) wealth. As wealth became the defining factor in legislation and political participation, securing that power base became more important than the bond of community that had been in place during formative years. (Women had the vote in New Jersey for a short period following the American Revolution—until the husbands who held the positions of power decided they were too fragile and impractical to decide important things. They did not get the vote again until the 1920s.)

The majority (white men) legislated their positions of power in a variety of ways, including exclusion of women and anyone of color from participation in the political process. Once excluded from the process for political decision-making, your status within the community and society is no longer stable; you are there at the whim of those who control the laws and economies. Blacks, mulattos, Indians and other identifiable free groups (Irish, Jews, non-Christians) were slowly and inexorably squeezed out. Slaves were pushed farther down the ladder of society.

In *Platform for Change*, Harry Reed argues that free black communities all across the antebellum North looked to five specific things in forming a community identity and "consciousness" to ease the harshness of their increasingly isolated status: the church, self-help organizations, black newspapers, the black convention movement and the ideology of immigration to Africa that began in the 1810s.[16]

Reed presents some interesting support for his belief that black community consciousness started from the need for individuals to support each other physically and emotionally within the shared confines of legal and social isolation. It follows Condeluci's discussion of community and social capital. Group identity blossomed into group consciousness once a few stalwart preachers established black Presbyterian, Methodist and Baptist congregations, with the support of a few white clergy. With freedoms won between the Revolutionary War and the 1820s, free black newspapers took up the call for unity, followed closely by black assemblies and conventions, political growth and social awareness. Support from a growing population of abolitionists assisted in, but did not lead, this process.

Clement Price sustains the idea that blacks and other persons of color assembled for the purpose of mutual support and to ameliorate their condition.[17] Establishment of black churches took the lead in his estimation, serving as social, cultural and religious outlets for these individuals and

families. This was followed closely by the establishment of mutual aid societies and fraternal associations.

Reed feels that the emigration movement, initially proposed as a solution to the growing numbers of free blacks and runaway slaves and adopted as a positive position by some black leaders, eventually led to the consideration of Canada as the goal of freed people. Efforts to immigrate to Liberia (promoted by the United States government), Haiti and Sierra Leone (promoted by some black and white leaders) and non-U.S. territories (Florida and Mexico) proved impractical or unpalatable. Life in the Northern states, though technically "free," offered little opportunity for work and economic independence. After the several state and federal fugitive slave laws were enacted, life in the North became nearly as dangerous as that in the South.

Canada, with its abolition of slavery early in the nineteenth century, evolved into the haven of choice. Letters were frequent from those who had gone there, tested the land and the potential and stayed to form small communities.[18] Thus, the North Star, in legend, tales, songs, tradition and reality, became one of the guiding signposts for self-emancipated individuals and families. (The tome by William Stills on the Underground Railroad contains a wealth of these stories; still good reading in this modern age.)

With prevailing laws and social attitudes prior to the Civil War, there was always the possibility of recapture, being kidnapped into slavery or being legally tricked regarding manumission papers—a variety of ways in which persons of color could become slaves. Even free blacks, those freed by manumission or never held as slaves, could be kidnapped and sold into slavery without great difficulty.

In the face of this, those referred to as "colored persons" formed their own communities in order to avoid harassment and provide mutual support. Some of these communities were village size (such as Gouldtown and Snow Hill), some were within or adjacent to the larger white cities or towns (such as Sadlertown, Marshalltown, Springtown and Timbuctoo) and most were located just outside existing town limits. They were present in the Deep South, as well as the only slightly less intolerant North.

These neighborhoods offered a refuge for the workers and servants required to maintain the larger, dominant communities but denied equal interaction within those communities. They also offered refuge and sanctuary to self-emancipated blacks who came into and through them on their way to freedom. They set the stage and provided the congregations for expanding black Methodist, Episcopal, Presbyterian and Baptist churches. They provided opportunity for blacks to grow and develop despite the segregated and restrictive settings of the larger society—teachers, schools and trade apprenticeships, rather than enslavement, were there.

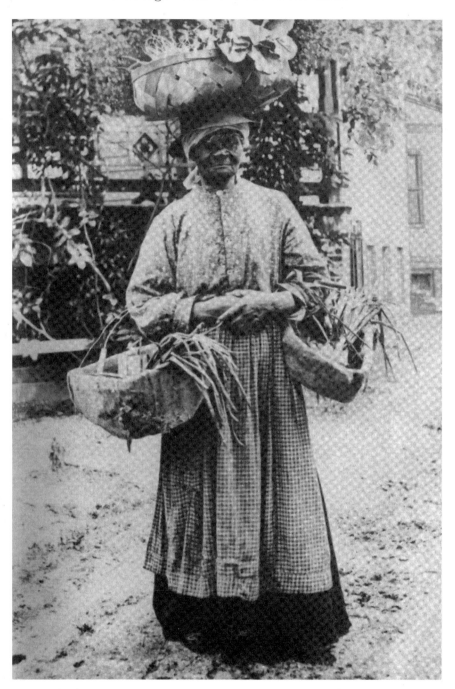

A woman carrying a basket on her head. This manner of carrying items hails from long-established tradition, passed down from generation to generation among families and groups of people. It is but one example of African and Indian practices that continued within the communities in discussion. *In Norman Yetman,* Voices From Slavery, *2000.*

An added dimension not often considered is that these locales and close-knit arrangements allowed for continuation of African, Creole and Native American skills and traditions. There are numerous descriptions of activity (dances and mannerisms within Christian worship), materials (the banjo and other instruments, basketry patterns) and customs (planting cedar trees and placing white shell rings around graves). These appear to come from native traditions carried through generations. As we might see today in a lost tribe in Brazil or the Philippines, the isolation allowed these traditions to continue generally unabated by influences from the surrounding community of Euro-Americans. However, it is doubtful that these small, isolated communities were established only to maintain tribal and familial traditions. They existed because they could not exist any other way. As Bell Hooks notes,

> *Those of us who remember living in the midst of racial apartheid know that the separate spaces, the times apart from whiteness, were for sanctuary, for re-imagining and re-remembering ourselves. In the past separate space meant down time, time for recovery and renewal. It was the time to dream resistance, time to theorize, plan, create strategies and go forward.*[19]

The fringe community was "the other side of the tracks," even before trains existed; close enough to offer gainful work for white landowners and merchants but far enough away to avoid trouble. Close enough to benefit somewhat from the table scraps of the economic system, but sufficiently aloof to preserve a sense of culture and community distinct and unique; a pride in self and family discreetly withheld in other settings. These were not simply temporary havens or loose communes, but truly parallel communities.

Chapter 2

Welcome to New Holland/Sweden/Jersey

That the American colonies fought against Great Britain for independence and that the common language of the country is an adaptation of the king's English can be blamed on poor planning and bad timing on the part of at least two other European powers. The Delaware Bay and River served as a reception area for Dutch, Swedish and English settlers from about 1624 on. No one had a firm hold on the territory during the early seventeenth century; the English were busy with Oliver Cromwell and a civil war, and the Swedes were gasping through the thirty-years war with the Holy Roman Empire (Germany).

Opening Scenario: Pardon Our (Sudden) Appearance[20]

After hearing about Sir Walter Raleigh's great success at Jamestown, Virginia (which was mostly hyped publicity at that point), and reports from the newly arrived Puritans in Massachusetts, the Dutch decided to secure their own imports from the New World. Years before, they had hired Henry Hudson to select a colony for them. Sailing under the Dutch flag, Hudson had come upon what we now know as the southern tip of New Jersey, but he could not navigate the many sandbars. Since no one had a firm concept of where this colony was supposed to be located, he simply moved up the coast to the river that now bears his name. A trading operation followed in 1610 at the tip of Manhattan Island in the entrance to the Hudson River, populated by only a few seasonal merchants and sailors. It was not really even a toehold on the vast continent.

In 1613, English captain Samuel Argall, on the *Discovery* from Jamestown, confronted the traders at Manhattan and forced allegiance and tribute to

the Virginia Colony. When he left, the traders re-hoisted the Dutch flag and went about business as usual.

Argall then successfully navigated the sandbars and entered the Syude Rivier (South River) Bay. In fashion with the traditional conduct of explorers, he christened it in honor of his friend, the governor of Virginia Colony, Sir Thomas West, Lord de la Warr. Thus, we have the river and bay called Delaware.

England, busy populating Walter Raleigh's adventure at Jamestown, left no settlers on this new land as yet. Spain was quite busy collecting spice, gold and silver from enslaved Indians in the Caribbean, Peru and Mexico and shipping it home. Habitually at war with England, Spain probably used at least some of the money to buy furs, slaves and timber from the Dutch. The Dutch patroons were projecting solid growth for their new colony and counting their guilders.

According to Israel Acrelius:

> *From that time until 1623, when the West India Company obtained its charter, their trade with the Indians was conducted almost entirely on shipboard, and they made no attempts to build any house or fortress until 1629. Now, whether that was done with or without the permission of England, the town of New Amsterdam was built and fortified, as also the place Aurania, Orange, [or Beaverwyck] now called Albany.*[21]

At this point, no one was really sure how far west this place went. Even though French trappers and priests had traveled as far inland as the Mississippi, communication between and among explorers was slow and restricted by royal politics and outright international antagonism. A parallel might be three prospectors with gold claims in California during the gold rush—no one told anyone else what he had found or where. Plus, there was no television news team embedded with those explorers.

Two years following the successful landing of the "Pilgrims" at Plymouth, Massachusetts (1621), the Dutch formed the West India Company. This was paralleled by the Dutch East India Company, which opened plantations and trade with the Pacific Rim. Master business people throughout the Middle Ages, the Dutch had been involved with trade (as well as slave trading and piracy) in the Caribbean for quite a while and decided the time was ripe to stake a claim in the upper reaches of this new continent, island or whatever it was.

It dawned on the Dutch that even insignificant religious outcasts like the Puritans could establish a colony and turn a profit. The Dutch figured

Welcome to New Holland/Sweden/Jersey

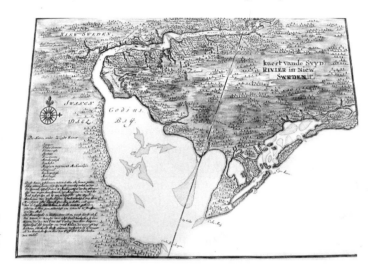

Vingboons'
early Dutch
map of New
Jersey. *Rutgers
University Maps
Collection, New
Brunswick, New
Jersey.*

that, with their experience in shipping, banking and trade, it would be a piece of cake. Besides, they already had those few stalwart traders at that seasonal trading post at the tip of what is now Manhattan. Explorers in their pay, Hudson, Block, May and Christiaanse, had surveyed most of what is now New England and New Jersey. Therefore, in an action typical of the egotism of Europeans of the day, they casually drew up a map, made precise calculations and staked claim on all territory from Cape Code to what is now Delaware Bay.

Unfortunately, the English had already prepared and signed a royal charter to the Massachusetts Bay Company and the colony at Jamestown. Based on these "self-published" documents, they had already laid claim to this same territory. The bickering began almost immediately.

Under Peter Menuit (Minuet, Menuet), Dutch immigrants settled at the sites of their two trading posts. They claimed the land that now makes up most of eastern New York and New Jersey for the Dutch West India Company. They supposedly made a nominal purchase for the privilege of using the facilities (the well-known twenty-four dollars in beads) but this has not been substantiated. Legend has it, though, that the natives who accepted the fee did not live on the land anyway. This could be the first official land swindle in North America.

Menuit, leader of the initial expeditions, had himself named patroon (leading citizen) and governor. In this capacity, Peter sent a few restless minions around the corner and up the river to the first spot visited by Hudson and Block. Maps of the time do not even show it as a river yet, since no one had gone that far inland.

The small outpost at Manhattan had begun to receive immigrants from Holland, and the territory was rechristened New Netherlands. The expedition to the south brought back descriptions of game and fish aplenty, and land ready for cultivation. In order to make a bold statement to the English about their claim to the territory, the Dutch decided to expand their colony southward. So they sent Captain Cornelius Mey and some settlers (all men) to populate and claim the area around the Syude River and Godyn's Bay (the Delaware according to the English). (At this same time, the French were sending Champlain and others to claim the land that would become Nova Scotia and Quebec, as well as parts of Michigan and Upper New England.)

Mey, besides giving his name to the point of land projecting into the bay at the southern tip of New Jersey, set up a trading post near what is now Gloucester City. Fort Nassau, a dirt and log encampment, followed later. The fort was manned by a small garrison (upwards of twenty men) who carried on trade with the natives and set up some small farms nearby. Traders traveled up the river with their Indian colleagues to Chygoes Island at present-day Burlington City. These initial settlers were left to their business, and the larger party and the ship returned to New Amsterdam (Manhattan).

Relations between the Dutch colony and the New England colonies were cordial but cautious. In 1629–30, the Dutch West India Company, under the direction of Peter Godyn, purchased tracts of land on either side of the South River (Delaware) from the local chiefs; this purchase comprised territory in current Cape May (New Jersey) and Cape Henlopen (Delaware) for two miles inland. This area was settled by a party of Dutch led by David Petersen DeVries in 1629–30. DeVries returned with supplies in 1632. Because of arrogance and stupidity in dealing with the Indians, the settlements at Swanandael (Lewiston, Delaware) and Fort Nassau had been reduced to ashes, the inhabitants killed or captured.

For our purposes, it is important to note that native practice at the time was to accommodate some or all captives (white men in this case) into the tribe as additional manpower and labor. Whether this occurred with the "lost garrisons" of Nassau and Swanandael is unknown, though there are reports from subsequent settlers of natives with curiously lighter skin, hair and blue eyes.

A Day Late—A Colony Short

Not to be outdone in this monumental land grab, the Swedes decided it was, in fact, they who really owned this land. After all, they had visited America in the year 996, had named it Vinland the Good (and also Skrællings Land) and, in a burst of creativity, had called its inhabitants "the Skrællings of Vinland." Therefore, it being evident that Northmen had visited some part of North America before the Spaniards and Portuguese went to South America, the land was obviously theirs. In 1626, under King Gustavus Adolphus, and at the urging of a Dutchman (William Usselinx) familiar with the trade in the new lands, they prepared to send a colony to the New World.

The Swedes prepared well, forming a trading company of their own for that purpose. They surveyed the area from existing maps and settled on the Syude Rivier as their destination. They outfitted a company for the voyage. Unfortunately, they got into a fray with Germany that was to last about thirty years, forcing the project to be put on the back burner.[22] When they returned to stake their claim, they found the Dutch and some English already carrying on a brisk trade and claiming first dibs.

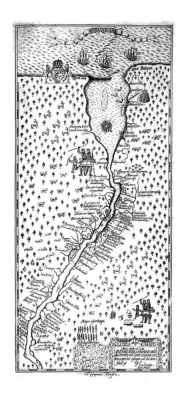

Holm, New Sweden, 1696. Titled: "Nova Svecia [New Sweden] by Th. Companius Holm, in *Lutheri Catechismus/ofwersatt på American-Virginiske språket.*" Published 1696. *Lawrence H. Slaughter Collection, New York Public Library.*

The initial establishment of colonies in the area was managed by the Dutch and the English. West Jersey (not to become this until sometime later) consisted of villages of Native Americans, with a few stalwart traders meandering through the countryside collecting furs. As we shall see, the Swedes and Dutch got into a fray a few years later, opening the door for the English to walk in and scoop up the whole territory.

By 1638, Peter Menuit, being a bit rough and unsociable, had become a burden to the Dutch traders and was sacked. Furious, and out of work, Menuit offered his services to the Kingdom of Sweden. At the time, this was controlled by Queen Christina and her six-year-old son, heir to throne; not the most promising of scenarios for a soldier of fortune. Nevertheless, Peter pressed the Royal Council toward establishing a Swedish and Finnish presence in the New World. His recommendation for a colony was the same bay between New Amsterdam and the Chesapeake to which he had dispensed the Dutch expedition in 1629.

Seeing an opportunity to rake in some much-needed extra funds, Queen Christina formed a trading company and hurried Peter off to procure profits. Minuet's Swedish expedition dropped anchor at Inlopen (Cape Henlopen,

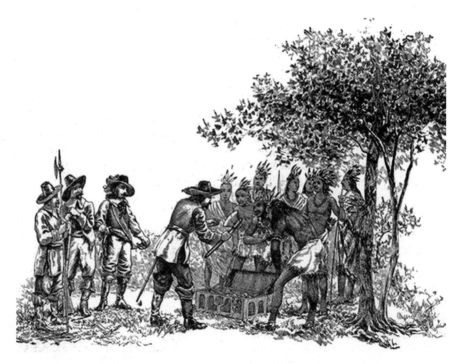

Peter Menuit and the Lenape in New Sweden. *New York Public Library Collection.*

Delaware). Several Dutch settlers challenged his landing. He maintained that he was merely stopping in for supplies. After the couriers withdrew, he moved his crew and settlers to the mouth of the Christina River, in what is now Delaware, hastily built a small enclosure and began a trading arrangement with the Lenape and Nanticoke.

EARLY EMERGENCE OF SLAVEHOLDING

At the same time, the area saw the influx of indentured and enslaved labor. Maintaining large farmsteads was not easy without a ready supply of manpower (and womanpower). Indentured labor was a common practice in Europe, particularly as a means of obtaining a trade or for securing passage to another place. In the case of New Sweden and New Netherlands, indenture was a way to rid the mother country of unwanted petty criminals and lost debtors by offering them a chance to move to the New World.

Some came as true slaves, their ownership a factor of working off fines and travel costs incurred by the owner on their behalf. Some came as indentured servants; they were expected to learn the master's trade and provide free labor while learning, in return for not being jailed or fined. Both referred to their owner/employer as "master."

Upon the end of their term, indentured servants were to be provided (by law) with a modest amount of funds, or land, and tools pertaining to their trade. Slaves had no such luxury except as provided by a beneficent master acting out of concern. Many were, in fact, sold to other owners as payment for debt and passed on down the line of inheritance until they ended their lives as slaves. Some were black, some were Indian and most (at this time) were white.

The Dutch, traders in all manner of enslaved populations, are credited with bringing in the first black (African) slaves to what is now New Jersey. A group of a dozen or so slaves is listed in the property of the settlers at Chygoes Island, at what is now Burlington.[23] While relatively insignificant, it was the start of a larger importation of slaves from Africa encouraged by British law and royal proclamation.

Black Anthony (Adolfus Fletcher), the first black man on record in New Sweden, arrived on the *Fogel Grip* in 1639 from Antigua in the West Indies. As the Swedes did not traffic in slaves, Anthony was emancipated. He served as a laborer for Governor Printz.[24]

Southern West Jersey was a slaveholding colony, as much as Jamestown. Trade goods manufactured in New Jersey and other Northern states supplied

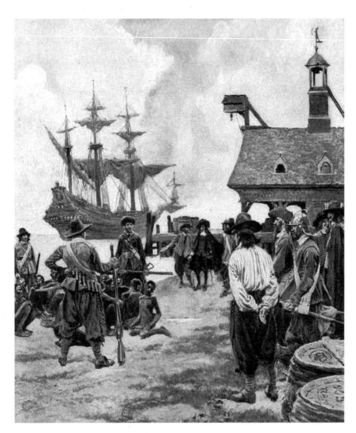

A Dutch ship
dropping slaves
at Jamestown.
From a 1901
illustration in
Harper's Magazine.
New York Public
Library Collection.

the need for cloth and shoes for slaves held in the South. There was differing opinion as to whether making a profit from slavery was the same as holding slaves. Active antislavery positions were common, and violent dialogues (and the occasional brawl) between advocates and slaveholders were frequent, even in the late seventeenth century.

Though subsequent social and legal changes allowed greater freedom for persons of color in Jersey than in the adjacent states of Delaware and Maryland, it remained a slave territory in conscience and practice until at least the mid-nineteenth century. One notable exception was among the Society of Friends and certain Methodist, Presbyterian and Baptist congregations, which gradually—then wholly—eschewed slaveholding and slavery. This exception was to prove to be of sufficient resilience to sustain legal and political challenge to the "peculiar institution" in the entire country and to offer opportunity for a resistance movement rooted in the common experience of colored, mulatto and black alike.

Chapter 3

Guests Who
Will Not Leave

No one asked the indigenous peoples what they thought about the arrangements being made between the Dutch, the English and the remaining Swedes. Being generally accepting of a variety of groups and cultures as part of their way of life, the resident peoples accepted the trade and interest of the newcomers, provided some degree of assistance and figured to live and let live. The trade goods brought over by the Europeans were tantalizing in their uniqueness and utility. The pelts and tobacco sought by this new, white tribe were plentiful and relatively easy to come by. It was a good deal, at first.

Trade with the Indians was not always in goods and beads. The traders, soldiers and colonists—all men, remember—took full advantage of the open social customs of the Indian culture. In several references it is noted that, within a short period of time after initial settlements, the taking of "squaw" wives became quite common. This was true for black as well as white settlers (remember, not all early arriving blacks were slaves). This intermixing continued throughout the development of the area and is really a statement about the demands of the situation rather than about any tolerance or acceptance by the Europeans.

The Lenapes and other tribes didn't bother to ask about the long-range business plans of the Dutch and others, or whether those plans included them. They were accustomed to sharing the stretches of land and forests in the region we now call South Jersey. There was enough for all, considering the limited scope of their populations.

Rather than a single tribe, the Lenapes consisted of several sub-clans and were, in turn, part of a larger group or coalition. All of the related tribes were loosely part of the Delaware Group, situated from the northern sections of what are now New Jersey, Pennsylvania and New York, southward to the Delaware Bay. These tribes shared similar custom and traditions, much as did other tribal coalitions such as the Iroquois and Sioux Confederacies.

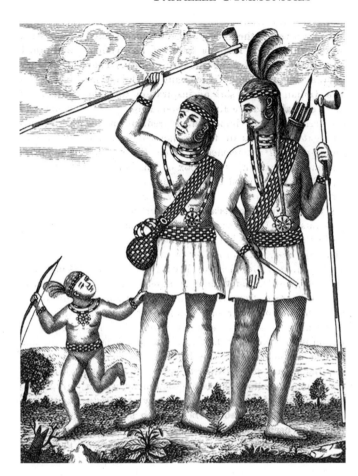

A Lenape family— somewhat stylized, but essentially accurate. *New York Public Library Collection.*

According to Chief Roy Crazy Horse at the Powhatan Renape Confederation website:

> *Essentially the term Renape refers to us as an ethnic group, a people speaking a common language. However, we were not all united in one Nation. Our people governed themselves freely and harmoniously as independent republics, which sometimes came together in alliances or confederations, such as the Powhatan Confederacy. Thus Powhatan refers to our political identity, while Renape refers to our ethnic/language identity.*[25]

Many of the Delaware sub-tribes, including the Lenape, were subordinated to the leadership of the larger Delaware and Algonquin federation, almost in the manner of medieval fiefdom. Local peace and prosperity were maintained by periodic tithes and services paid to this leadership from among the tribes,

for which the smaller tribes received support and security. An indigenous protection racket, so to speak.[26]

The native name for the river, *Lenape Wihittuck*, simply means "River of the Lenape." This really is not so strange if you consider that the current name of the river is merely an honor to Lord de la Warr, as noted, given in much the same way we now name highways and streets after famous people. The Lenape simply gave the body of water a name reflecting its significance to them—their source of water, transport and food.[27]

Os Cresson notes:

> *The Lenape lived in a longhouse and huts made of saplings and bark. The families were organized around the female line of descent, with men moving to the woman's longhouse upon marriage. Here they carried on much the same range of activities we do today. They sang and enjoyed the music of flutes, rattles, and drums. The children played games and the*

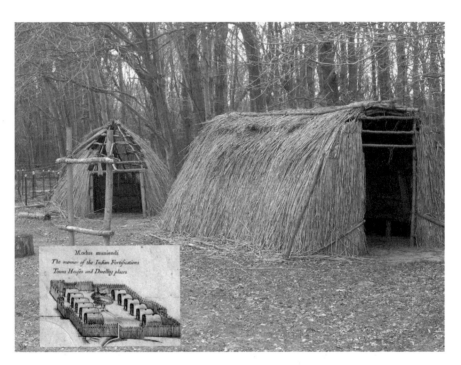

A typical Lenape longhouse dwelling. Several might be located within a low stockade (see inset detail), the fencing being as much to keep domesticated animals inside as wild animals and intruders out. *Powhattan-Renape Museum, Westampton, New Jersey. Author's photograph.*
Inset: Detail from a 1677 map by Englishman John Sellers. The map erroneously indicates that New Jersey is an island. *New Jersey State Archives, Trenton.*

adults told stories. The Lenape wore buckskin and furs, carefully sewn and adorned. They painted and tattooed themselves and wore jewelry. They had community meetings and religious ceremonies. Nature was sacred for them and they laid their dead to rest in burial grounds and believed in an afterlife that was determined by how you lived your life on Earth.[28]

Semi-permanent villages existed to allow for seasonal harvesting and hunting. However, hub villages existed to provide for cultural activity, as well as a sense of cohesiveness. An important hub for the tribe was along the Cohansick River, near modern-day Bridgeton.[29]

According to Bessie Ayers Andrews:

The wigwams in West Jersey were mostly roofed with chestnut bark, and sewed together with string slit from maize stalks. They were close and warm, and no rain could penetrate them.

Travel in the seventeenth century was less than comfortable. Come to think of it, not much has changed. At the end of a modern journey, however, one has the option of a comfortable, well-appointed hotel room, with maid service, a concierge, a bar and restaurant serving local cuisine and a soft bed.

The Swedes and Dutch lived in nothing even remotely as comfortable. At the end of the three- to six-month voyage in 1627, across the rough Atlantic Ocean in the forty- to sixty-foot caravels, galleys, carracks, naos, pinnaces, galleasses and galleons used at the time, was open woodland and riverside caves. Log huts and cedar cabins were the purview of high society and of wealthier travelers. Occasionally, the Lenape would share their dwelling and building styles with the new arrivals.

Once a critical mass of settlers was achieved, there would be the urge to establish a community; a place of mutual communication and collaboration, usually surrounding a mill and/or church. Early communities would have been built along the lines of the home country, as with the houses of Swedish settlers in Salem County. They were almost always clustered along the main means of transport—creeks and rivers.

Settlers arriving after the establishment of small enclaves, about 1640–60, might find a small hovel or dirt-floor barn in which to reside while building a homestead. Of course, this same resource would need to incorporate any of the other families coming over, their servants, slaves, animals, etc. If you settled near the fort, you might find some comfort in the few dozen

Guests Who Will Not Leave

A reconstructed example of an early farm complex, common in the area of New Sweden. *In D.G. Raible,* Down a Country Lane, *Camden County Historical Society, 2000.*

Dutch barn style—Gloucester County. These barns, with the wings resembling the old-fashioned Dutch woman's cap, are common sights even today in Salem, Cumberland and parts of Gloucester Counties. *Library of Congress, American Building Survey.*

professional soldiers stationed there, with their matchlock muskets, pikes and small-bore cannon.

Peter Kalm, the Swedish traveler and botanist who was here among his countrymen in 1748, noticed the following:

> The ancient Swedes used the sassafras for tea, and for a dye. From the persimmon tree they made beer and brandy. They called the mullein plant the Indian tobacco; they tied it around their arms and feet, as a cure when they had the ague. They made their candles generally from the bayberry bushes; the root they used to cure tooth-ache; from the bush they also made an agreeable smelling soap. The magnolia tree they made use of for various medicinal purposes.[30]

STILL HERE: THE INDIANS

As noted, the primary tribal group in Delaware and Southern Jersey were the Nanticoke Lenni-Lenape, though there were even smaller subgroups of this. The coalition lived on either shore of the river and bay, traveling throughout the region hunting and gathering. The continued tribal presence in Southern New Jersey has been the subject of much debate and discussion over the centuries. Despite claims to the contrary, many descendants remain in the area of what are now Cumberland, Salem and Cape May Counties.[31] Louise Heite describes the conditions for this and the Delaware Moors, known to be a distinct peoples in that area. It is likely this group inhabited lower New Jersey as well.

> In the 17th century, the settlers of Jamestown described the "tawny half-breeds" they encountered in the forests, who strangely preferred the freedom of the wilderness to the safety and comfort of Jamestown. Who were these people, these "half-breeds"? Theories as to the identity of this people range from the romantic (the survivors of the Roanoke colony) to the fantastic (the descendants of early Viking, Welsh or Phoenician settlers). In fact, they were members of fugitive (also called maroon) communities that existed on the outskirts of European settlement from the earliest days of colonization.
>
> Whichever, if any, of the legends is true, the fact remains that the Delaware Moors are most likely a mixture of the Native American tribes that occupied the Delmarva region (Nanticokes and Lenni Lenape), European whites, and Africans of some sort. The Moors perhaps best illustrate the singular status that tri-racial groups occupy in America. Being barred from

*attending the white schools of Kent and Sussex counties, and refusing to
attend the African American schools of the area, the Moors created their
own schools. The Moors, like most other tri-racial groups, did not consider
themselves part of either the white or African American communities.
Although Indians, whites and blacks could marry into the group, once they
did so they became part of the tri-racial community.*[32]

In the face of clear presentations and traditions by anthropologist Herbert
Pierce and many others, most authorities (and the public) assumed the
indigenous populations had completely disappeared when the main villages
moved West (Oklahoma) or North (Canada). A town adjacent to the Six
Nations Reserve in Southern Ontario bears the name "Nanticoke," attesting
to the adoption of this tribe by the Six Nations confederation.

Presbyterian minister to the Indians John Brainerd is clear in his diary
that he served several communities in Southern New Jersey that consisted
of Indians, whites and blacks together. His district ministry was centered
in Brotherton, the reservation near what is now Indian Mills in Shamong
Township (Burlington County). Yet, he specifically mentions ministering to
the Indians living in Southern New Jersey at Bridgeton and Cohansick.[33]
When Brotherton was abandoned by the final few Native American families
still following the traditional ways in 1804, it was assumed the Indians had
left New Jersey. Not so.

When he was growing up in the 1950s, master drum maker Herbert C.
Pierce, a Native American of the Nanticoke Lenni-Lenape tribe in South
Jersey, found his heritage was an embarrassment.

*In my parents' day, our people did not talk outwardly of their Native
American heritage. They feared being sent to reservations in Virginia or
Oklahoma.*

*When I was born in Bridgeton, NJ, my mother told me I was Irish
Indian. Being related to Carneys made me Irish, but I was also related to
many Native American lines through the Pierces in Cumberland County
and the Dunns of Salem County.*

*To keep our traditions alive, we would gather at the Fordville United
Methodist Church, now designated by the Methodist conference as a Native
American church. My wife Maybelle grew up in Gouldtown which was
founded by Native Americans. Her father Jesse Gould, also called Golden
Eagle, showed me how to make an Indian drum the way our ancestors
made them.*[34]

It was similarity in experience that drove the Indian, the black and the white servant to join in labor and in life. People who live, eat, sleep and work together eventually learn much about one another, and interrelations are not far behind. Perhaps it was an instinctive awareness of this social behavior that resulted in many of the early laws prohibiting interaction between whites, blacks and Indians.

In any event, as the colonists were building their new world, many found companionship and support across race and class. The Lenape, decimated by disease and elbowed off their land, found sanctuary among some of the new immigrants; these new immigrants, in turn, found helpmates and extended family by their relationships to the indigenous peoples.

FENWICK'S COLONY: RETURN OF THE ENGLISH

Around 1642, Peter Menuit died at the colony in Christiana. He was succeeded by Peter Hollandare, whose only claim to fame during his twelve months of tenure was to join with the Dutch in a drive to remove all English settlers from the South River (Delaware) area. Hollandare was replaced by John Printz, who went on to become a most effective and beneficial governor of New Sweden. In compliance with the wishes of the crown that he arrange to "block up" the river if necessary, he built a second fort at Tinicum Island (Fort New Gottenberg) and a third at the southern shore of Varcken's Kill (Salem Creek). This third was called Fort Elfsborg, now indicated by a marker and park situated near modern-day Oakwood Beach in Elsinboro Township (New Jersey).

> *After Printz returned to Sweden in 1653, Fort Christiana (near present-day Wilmington, Delaware) again became the capital of the colony. Tinicum and Printzhoff became the possession of his daughter Amegot Printz Papegoja, who in 1662 sold the island to a Dutch settler Joost de La Grange for the princely sum of six thousand guilders. Archaeological digs in 1937, 1976 and 1985 uncovered a number of artifacts and the foundations of the Swedish governor's mansion. Today, the former capital of New Sweden is home to the Corinthian Yacht Club and Governor Printz Park.[35]*

Tinicum Island, set off from the mainland primarily by swamps and marshland, is now known primarily as home to the Philadelphia International Airport. A small park affirms the location of Fort New Gothenburg. From

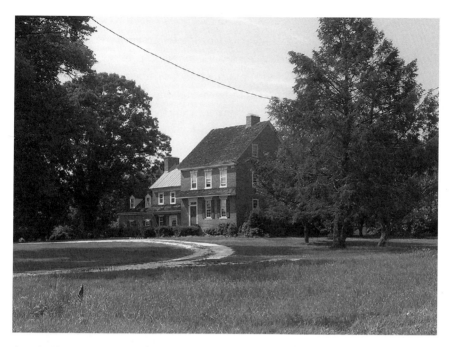

A typical large plantation house in Southern New Jersey. Many of these are being maintained as family homes even as the land surrounding them is sold off as fodder for large-scale commuter housing developments. *Author's photo.*

this point, the Swedes harassed the Dutch, who consistently harassed them back. The English bided their time as the Dutch and Swedes went through this arguing and fighting over the lands between Jamestown and Plymouth. Besides, they were busy with Oliver Cromwell and the English Civil War. R.C. Koedel notes:

> *Never having relinquished her claim to the coast of North America, the island kingdom struck in 1664, four years after the Stuart Restoration. In that year, Charles II awarded to his brother James, the Duke of York, all the lands lying between the Connecticut and Delaware Rivers, to be apportioned and governed as he chose. The duke, in turn, gave to two court favorites, Sir George Carteret and John Lord Berkeley, the territory lying between the Hudson and Delaware Rivers, decreeing that the "said Tract of Land hereafter is to be called by the name or names of New Caesarea or New Jersey."* [36]

James, in a bid to reestablish not only England's claim to the middle colonies, but also his claim to the throne, sent a flotilla to kick the Dutch

out of what was (in his mind) clearly English territory. By this time (1665), Dutch control was foundering because the home country was losing the battle for control of trade in the Atlantic and Caribbean. Sweden's hold on its colony was also subservient to England once the flotilla (under Sir Robert Carr) came through the Delaware Bay and up the river. There was simply not enough manpower to resist the English, who were fresh from internal fighting and very good at military adventure.

James "sold" the land he didn't own in the first place to George Carteret and John Berkeley. Carteret and Berkeley, probably over a bottle of Claret, divided their prize between East Jersey (eventually headquartered in Perth Amboy) and West Jersey (eventually headquartered in Burlington). Lord Berkeley was not known to hold on to money when it could be squandered in some lame adventure or card game. Financial entanglements rendered him insolvent, causing a need for immediate hard cash. Koedel writes:

> *Thereupon, he sold his half of New Jersey, an area as yet undefined, in a transaction of March 18, 1673 with John Fenwick, a member of the Society of Friends, for the price of 1000 pounds. Fenwick made the purchase as the agent of another Quaker, Edward Byllynge. Because Byllynge was in financial trouble at the time, he could not consummate the deal on his own behalf without risking devastation by his creditors. Eventually, his affairs became so involved that three Quakers of substance and ability, among them William Penn, were appointed trustees of his estate until he could be extricated from his financial woes.*[37]

The region to be settled was divided into one hundred shares, or proprieties, to be sold at the usual price of £350 each. This was a £34,000 profit over the original sale price. Not bad. (It certainly was a harbinger of the modern real estate explosion in the area.)

John Fenwick, a former officer in Cromwell's army, acted as agent for Byllynge. Of course, Fenwick's fortune had been tied to Cromwell's in England. With the fall of that chief, he had to make a quick shift of party affiliation to keep his lands—and his head. How he worked the system to get a party of colonists deeded by the king's favorites (against whom he had fought) is not for our discussion, but it would probably make interesting reading. One might suspect he simply had sufficient ready cash to buy his way back into favor.

Any purchase of a share, or a part thereof, carried with it the right to participation in the government of the province. Ten of the shares were allotted to Fenwick in recognition of his part as Byllynge's agent in pulling

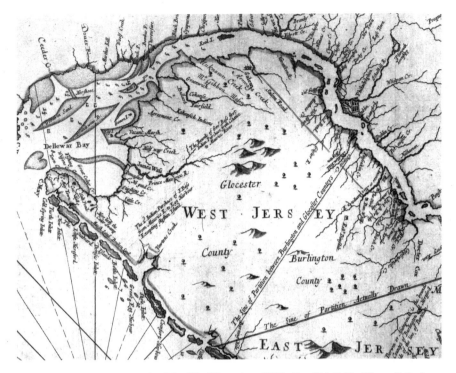

An English map of the area by John Worlidge, circa 1706. *New York Public Library Collection.*

off the transaction with Lord Berkeley.[38] Fenwick, having negotiated the original deal and having a large amount of his own money sewed up in the transaction, was miffed. He determined to go it alone. According to Koedel:

> *Having organized an expedition, Fenwick and his passengers sailed for America aboard the* Griffin *in early autumn, 1675. They arrived on the Delaware, at the mouth of Varkens Kïl [Salem Creek], in November. The place of their landing Fenwick called New Salem, because of the "delightsomeness of the land."*

Fenwick, with his company of nearly two hundred, came from London on the ship *Griffin* and "landed at Fort Elfsborg on the 9th month (November, in the old style calendar) 1675, and so on up to New Salem where they did inhabit." The exact date of the first arrival of the *Griffin* has been the subject of much discussion and probably will never be accurately determined. The first deed made by John Fenwick with the Indians is dated November 17, 1675.[39]

The territory, which was called Salem Tenth, that Fenwick had acquired in West Jersey before leaving England extended from what is now Oldman's Creek on the north to Back Creek (now Cumberland County) on the south. The colony was divided into six subdivisions, or hundreds, namely:

East Fenwick
West Fenwick
New Salem
Allowayes
Little Chohansick
Great Chohansick

Fenwick started with the village and county of Salem, naming it in response to the peaceful meadows and good climate. The land was far more fertile than that on the Delaware side of the bay, immediately opposite. The eastern boundary was a straight line drawn from the headwaters of the Cohansick to those of Oldman's Creek. The western boundary was the Delaware River. In 1748, Cumberland County was set off from Salem County.

Settlers based their land ownership on the traditions of their home country. Grants of real estate from the English king were passed through favorites in court and allotted by them to friends and colleagues. The Colony of Jersey, bounded primarily by the Delaware and Hudson Rivers, followed this same process in the division of its land among early groups of stockholders, proprietor's agents and patrons.

In 1677, the *Kent* arrived. In October, they made landfall at Raccoon Creek. At Raccoon, these Yorkshire and London Quakers enjoyed the hospitality of the Swedish settlers until they could negotiate a land settlement with the Indians and select a site for a village. They agreed upon a Delaware River location several miles upstream from Raccoon, where they established a town called Burlington, the nucleus of what would become the second most prominent Quaker community in America, after Philadelphia.[40]

Quickly, other ships sailing from English ports bound for West Jersey brought Quakers to the shores of the Delaware. By the middle of 1679, their numbers had increased to a whopping eight hundred. A group of Irish Quakers left Dublin in 1681 to settle the Irish Tenth, the area comprising part of what became Gloucester County.

The influx of Quakers to New Jersey lessened considerably after 1682, when William Penn transferred the center of Quaker settlement in America to his new colony of Pennsylvania. Nevertheless, by the end of the

seventeenth century, of a total West Jersey population in excess of thirty-three hundred persons, more than two-thirds were Quakers, and another one thousand were Swedes and Finns. English-speaking people of other religious persuasions had also begun to settle the province, though in lesser numbers. The principal religious makeup of West Jersey was Quaker.

The immigrants carried with them the tools of their religion, their trades and their culture; this included indentured servants and slaves. The first slaves came with the Dutch, and the English brought more. The Quakers at this point, were not opposed to slavery in the least. The cheap labor of slaves and indentured servants was critical to the operation of the system. Profit was the name of the game.

As Koedel notes:

> *From a wilderness, the western edges of South Jersey were transformed, in the 1698 description by Gabriel Thomas, into an idyllic, peaceful English countryside, with an air that was "very clear, sweet and wholesome." Fenwick's "pretty town" of Salem sat amid orchards of apple, cherry, pear, plum, and peach trees. They were "the natural product of this country, which lies warmer, being more befriended by the sun's hot and glorious beams, which without doubt is the chief cause and true reason why the fruit there so far excells* [sic] *the English."*

By the 1700s, West Jersey had become colonized. The Indians were essentially eliminated as an influence through disease and economic exploitation. The remnants of the Lenape from the southern part of New Jersey coalesced around the town of Brotherton. The mission of John Brainerd there gave them some sense of protection and cohesiveness.[41] The white population in the area under discussion had increased and established numerous small villages and at least the following larger towns: Salem, Greenwich, Bridgeton (Cohansey), Cape May, Woodbury, Swedesboro (Raccoon), Haddonfield, Mount Holly, Evesham, Burlington and Bordentown. Every mill site became a named location, such as Sheppard's Mill (near Greenwich) and Hendrickson's Mill (near Swedesboro).

Adjacent to these larger and smaller white communities were what Jim Turk has called "fringe" communities and what Edward Heite referred to as "isolate" communities.[42] It is these places that have had little or no exposure in the literature over the years. Some still exist as communities, some have withered into the landscape and some are just barely discernable through the members of one or another church congregation originally tied to the enclave.

While descendants of the founders and residents of old recall stories from great-great-grandpa, and locals recall former places in various ways, these have been all but forgotten by the general public. Yet, it was these communities, in collaboration with a strong and vibrant black-colored-white underground, that served as the conduit for many hundreds, possibly thousands of self-emancipated persons in the period leading up to the American Civil War. The legacy of Fenwick's Tenth was about to be set.

Gouldtown—
A Very Ancient Diverse
Community

Item: I do except against Elizabeth Adams of having any ye leaste part of my estate, unless the Lord open her eyes to see her abominable transgression against him, me and her good father, by giving her true repentance, and forsaking yt Black yt hath been ye ruin of her, and becoming penitent for her sins; upon yt condition only I do will and require my executors to settle five hundred acres of land upon her.[43]
—*from John Fenwick's will, 1683*

E lizabeth, nineteen years old at the time of the death of her grandfather, never acceded to his request. Whether this was due to love, spite or indecision will never be known, though it is always sanguine to think of it as due to love. Remember, black, white and Indian slavery were common at this point, and anyone of color was suspect, regardless of his or her capability and economic standing. In addition, though intermarrying was not uncommon in the early years of the colony, it was still frowned upon, at least by the English. The various peoples came to rely on one another for survival, and there simply was not a great body of eligible spouses from which to select. As noted, the formulation of communities of color was spawned by necessity, even at this early stage.

A VARIED LINEAGE

Elizabeth's parents had lands in what is now Bacon's Neck, in Cumberland County. That Gouldtown is on the opposite side of the Cohansey River from Bacon's Neck (about three miles from Cohansey Bridge, or Bridgeton) would indicate that the unrestrained daughter settled at the fringe of the main community. At that time, there were numerous Lenape and Nanticoke remaining, as well as Dutch and Swedish settlers many of whom had

intermarried with the Indians and blacks. The couple would have been accepted, or at least not frowned upon in such a setting. (Note that Elizabeth's only known child, Benjamin, married Ann, a Finn, from the area.) According to G.M. Cole:

> *Gouldtown is, itself, a unique community. It was founded around 1700 by Benjamin Gould his marriage to Ann (a Finn). He was the youngest of five children by Elizabeth Fenwick Adams and a man of color named Gould. Elizabeth Adams was the granddaughter of John Fenwick, the proprietor of Salem County. Other Mulattos soon settled here. Anthony and Richard Pierce came here from the West Indies on a merchant ship and stayed. They paid the passage of two Dutch women who became their wives. The Murrays came here from Cape May and claim a Lenape Indian ancestry. Othniel Murray married a Swede named Katherine. Before the Revolution, these three families had intermarried among themselves and with other white settlers. The early inhabitants were members of the Old Stone Church.*[44]

The migration of peoples into Southern New Jersey during the 1600s and 1700s resulted in a great amount of cross-pollination; cultural, economic

The Old Stone Church, Fairton. *Library of Congress, American Building Survey.*

and physical. Dutch and Swedish immigrants had formed bonds in the face of the resurrected English claims, and the white Europeans had banded together in dealings with blacks and Indians. The existence of "tri-racial" communities is well documented, though not well publicized in history books. Michael Kolkoff notes:

> *In the period prior to the Civil War, tri-racial people were classified as "free persons of color," a classification which has led many researchers to erroneously identify tri-racials as freed slaves. After the Reconstruction period, with the rise of the Eugenics movement of scientific racism, tri-racial groups were classified as African Americans in many locations (based on the "one drop" rule: if you have ANY Negro ancestry, you are a Negro). These measures did much to destroy many tri-racial communities, since those who could "pass for white" eagerly did so to avoid the racist restrictions placed on Negroes. Those tri-racials who exhibited the most prominent Negro features were forced to dissolve into the African American community, where they became "mulattos." Those that exhibited the most prominent European features dissolved into white society, where they explained their dark features by various acceptable means. Tri-racial communities still exist, and many occupy lands that their fugitive ancestors settled generations ago.*[45]

Gouldtown represents an early and well-documented example of socially remote groups, which are the subject of this book. As a truly tri-racial community, Gouldtown has given rise to generations of Goulds, Pierces, Cuffs and Murrays over the centuries. It is a small community in population; many of the original family members having long ago moved to the cities and to other states for business, work or school. The extended family of Goulds meets annually for a reunion that is very large and diverse, and demonstrates pride in family history and longevity.

Elizabeth's descendants and others who sought an escape from the rigorous rules and laws of the early settlements founded a diverse community of just a few families. The Pierces, Goulds, Cuffs and Murrays each held farms in the traditional manner, dividing these in wills among children, but retaining their "family section" of the land around Cohansey Bridge and Fairton. These families of farmers, merchants and mechanics intermarried, bringing others into the fold as the years passed. The community has stood the test of time and remains a part of the rural landscape east of Bridgeton, New Jersey.

John Brainerd, noted Presbyterian minister, is known to have preached to families of whites, blacks and Indians in this area as early as 1758.

There is Cole's reference to them attending worship at the Old Stone Church, where a gallery was built to accommodate "the Gouldtowners." Such connections indicate that the early Gouldtowners were a natural part of these meetings and congregations, and they broke off only later to maintain an African Methodist Episcopal church and a Baptist church. It is likely that they were segregated into that gallery rather than afforded seats in the main chapel.

Paying for the passage of women as wives was quite common in the era, when the vast majority of settlers were men. That Anthony and Richard Pierce did so is not unusual. That they selected "Dutch" women might seem odd until one remembers that the area was heavily invested in by Dutch families descended from the original New Netherlands Colony and Swedes from New Sweden. A hardworking man with land and a means of supporting a family required a wife and was a good catch for someone's relative seeking to move to the New World.

> *When Benjamin Gould, the founder of Gouldtown, grew up, it is quite probable there were no girls of his own color with whom he could associate had he desired to do so; that he had brothers and sisters to grow to maturity has not been established, but the tradition handed down through his sons is that his parents had five children, one of whom was a son named Levi; all the others died young, and all trace of Levi was lost before the death of Benjamin. It was held that Levi was older than Benjamin. Benjamin married a Finn, whose name was Ann; he got none of the Fenwick land, nor any of the lands of his mother's father, John Adams, so far as can be learned.*[46]

Correspondence was widespread in those days, though requiring weeks or months to reach its destination. It is highly likely that descendants of the original Dutch settlers wrote home to family and benefactors on a regular basis. Mention of an eligible daughter, and an equally eligible suitor in the New World, would not have been unusual. In addition, a free black man in West Jersey in the early 1700s could conceivably find himself without a reasonable selection of free black women. To marry a slave meant that the children of that union would be slaves; not a desirable picture for someone building a legacy. Therefore, he must find a suitable and practical spouse from whatever source was available.

Theopholus Gould Steward, historian of Gouldtown. *New York Public Library Collection.*

THE PLACE

In a part of Cumberland County, East of Bridgeton off of Route 49, lies the ancient community of Gouldtown. Recognized as an independent entity as early as 1750, Gouldtown has maintained its heritage through the centuries. The families of the pioneers who settled here have expanded throughout the world. Gould, Pierce, Murray, Cuffe (or Cuff) and Wright—the names are still here, as are the stories and legends.

Gouldtown is located on Route 543, lying within modern Fairfield Township, New Jersey. It has been a community of multiracial citizens since inception and has been noted as such in studies and stories through the centuries. It is also one of the more familiar of the towns, thanks to a generous helping of history dealt up by one of its sons. Theopholus Gould Steward, a military chaplain with colored troops during the Civil War and after, prepared a history of his family and hometown in 1913 that remains one of the most widely read texts on multiracial communities.[47] Gouldtowners maintain a proud and rich heritage.

In the Works Projects Administration Tour Book of 1939, Tour #29, some general social bias comes through, but it is a good picture of the lifestyle as late as the Second World War. Not much had changed in two hundred years.

> *GOULDTOWN, 26 m. (85 alt., 700 pop.), is a colony of mulattoes, the descendants of four mulatto families that have intermarried for more than 175 years with only an occasional infiltration of other blood. These four families were named Gould, Pierce, Murray, and Cuff. The Murrays are believed to be of Indian descent; and the original Cuff was a slave who married his former master's widow. The residents of Gouldtown are a hard-working, highly respected people.*
>
> *The community stretches for several miles along the highway and nearby dirt roads. The houses, mostly small and weather-beaten, are set off in small farms. It has always been a problem for Gouldtown residents to wrest a living from their scanty acres, and the countryside bears evidence of the struggle. The general effect of Gouldtown is somewhat subdued in keeping with these people who refuse to accept a Negro status, but cannot be classed as whites.*

The town or section of Cumberland County called Fairfield or Fairton (modern Fairfield Township) was developed by settlers arriving from Connecticut. These settlers received charter from the local proprietors and established a community. G.M. Cole notes:

> *The first settlers from Fairfield, Connecticut and Long Island called their settlement, New England Town and located it at the head of the present day New England Cross Roads. On June 10, 1697, these settlers formed the First Presbyterian Church of South Jersey. Today a granite monument (dedicated 1909) stands on the site of their first log meeting house. The cemetery which adjoined the meeting house remains the oldest in the township. Around 1717, a frame meeting house with shingle siding replaced the log one. By 1775, the building was declared unsafe so the congregation purchased the ground where the Old Stone Church still stands.[48]*

Gouldtown is also a living testimonial on insular and self-serving laws, social mores and attitudes that attempt furtive management of race relations and continue to this day in New Jersey.

If one enters into the spirit of Gouldtown and reads hastily the dry, Isaac-begat-Jacob passages, Steward's study moves like the story of a river that loses itself in the sands. "Samuel 3rd. when a young man went to Pittsburgh

Gouldtown—A Very Ancient Diverse Community

A view of Gouldtown Road. The landscape remains rural and the homes small. *Author's photo*.

then counted to be in the far west and all trace of him was lost"; "Daniel Gould...in early manhood went to Massachusetts, losing his identity as colored." Such expressions are typical of the whole study. A constant fading away, a loss of identity occurs. The book is clearly the story of the mulatto in the United States.[49] As Walter Dyson notes further (with a hint of the stereotypical attitudes of the era):

> *For over 200 years these descendants have married and inter-married with Indian, Negro and White with no serious detriment except the introduction of tuberculosis into one branch of the family by an infusion of white blood. It is interesting to note that crime, drunkenness, pauperism or sterility has not resulted from these two hundred years of miscegenation. Thrift and intelligence, longevity and fertility have been evident.[50]*

Driving through the area, it is impossible to note a change of venue, a distinct entrance or exit to this community. Gouldtown Road intersects with the county route near the present-day Baptist church. The hereditary acreage of Goulds, Pierces, Cuffs and Murrays spreads over a wide swath southeast of Bridgeton. Small farms remain the staple image, though modern construction and developments are encroaching; evidence of the change of the primary occupants of the area from farmers to commuters.

Gouldtown Trinity Church, at the crossroads of Gouldtown Road and Route 49. *Author's photo.*

The community has been celebrated locally and in national press over the years as a primary example of the diversity of American culture and the thrift and productivity of the descendants of black and Indian settlers. At times the references are somewhat condescending; other times the stories exude pride and achievement. Theopholus Steward, in his history, points out that the citizens and descendants of the Gouldtowners demonstrate that a community that is diverse can be as productive and responsible as any other. This, more than likely, was in response to the generations of denigration leveled at colored and black communities.

The first school in Fairfield was located at the crossroads of Burlington Road and the Fairton–Millville Road. Bennett Town School, as it was known, was sponsored by the Old Stone Church. It served the children from Gouldtown, as well as the area south of Gouldtown.

After 1805, Gouldtown became the site for the tollgate on Bridgeton–Millville Road. The tollhouse was located just west of the church on the road to Bridgeton. Travelers were required to stop and pay a toll. A trolley ran from Bridgeton to Millville, providing transportation for the citizens of Gouldtown.

A post office was situated on the corner of what is now Route 49 and Gouldtown–Fairton Road. Its last postmistress was Mrs. Anna Gould Pierce. A few years later, a grocery store was built across the road, with Mr. Charles Bryant, proprietor. Cole writes:

Gouldtown—A Very Ancient Diverse Community

During the days of commercial shipping, several wharves held prominence within the township. The first was the Donaghay-Dailey Landing at the site of the Cohanzick Country Club. The chief export was cordwood, firewood and salt hay cut by the Gouldtowners during the winter. Vegetables, salt, and hay were the other products which were exported.[51]

Many of the landowners in this part of the state possessed a section of marshland in which grew quantities of salt hay. Before the cultivation of soy and hay that is common today, this hay would be harvested each year and put by to provide forage for the animals of the farm over the winter. This process continued into the nineteenth century, even though the most prominent use of the hay at that point was for packing glass.

The community, in 1913, possessed

two churches situated about a mile apart, one a Methodist Episcopal, and the other an African Methodist Episcopal; the latter being in the village, the former in that part of the neighborhood now called Fordsville, the congregation of which is dominated by the Pierce family, while the Goulds are the dominating family in the African Methodist Episcopal Church.[52]

In going through the area, one sees Gouldtown Road, Piercetown Road and many references to Murray and Gould family names. The 1876 map of Cumberland County notes many homesites of Gould, Murray, Pierce and Cuff. Some ancient buildings remain, in modified form, giving an indication of the style of construction from an earlier period. One house

The sheriff's sale posting noted that one Anna Murray was the last owner. This form of building continues to be found throughout the South Jersey area and corresponds with Maria Boynton's description of early black/colored community construction techniques and the Robinson House in Springtown, New Jersey. *Author's photo.*

was located showing the common style of the African and Southern United States influence noted by Maria Boynton in her discussion of Springtown (see chapter 5). The foundation indicated the house was not ancient, had probably been moved or improved upon over the years and, yet, the style remains consistent with that of numerous dwellings in the area—simple and rustic, particularly in light of the image of New Jersey seen along the turnpike and parkways.

THE PEOPLE

T.G. Steward often relates tales from John Murray, an original descendant and son of Othniel and Katherine Murray. John died at the age of 102; his wife, Tabatha, died at the age of 96. Steward recalls many stories told by Murray, whom he saw regularly on his walks to and from the house of his great-great-grandfather, Benjamin Gould:

Rebecca Gould Steward, mother of T.G. Steward and descendant of Benjamin Gould. *Gould Family Photos, New York Public Library Collection.*

Gouldtown—A Very Ancient Diverse Community

The four sons of Benjamin and Ann Gould were associates of John Murray and his brothers and sisters in their boyhood and early manhood days. The sons and daughters of Anthony and Richard Pierce were also companions of the sons of Benjamin Gould. [John Murray] *was a brusque and eccentric old man, and had had both feet cut off. His farm was infested with sand burrs and, working in his bare feet, he got the burrs in his feet and gangrene ensued and both his feet were amputated.—While I heard stories of how Uncle Johnnie would fire his crutches across the house at Aunt Tabatha when angry, I never saw anything of the kind.*

Steward is more discreet with members of his own family than those of the others. He attributes this to their heritage from the Fenwick and Adams lines. It would appear that he was somewhat of a teetotaler as well.

The Quaker solidity and quiet dispositions inherited by the Goulds may be traced to this day; the Dutch superstitions are still apparent in the Pierces;

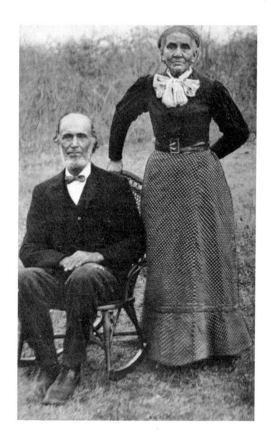

Jacob and Ann Wright, citizens of Gouldtown. *Gould Family Photos, New York Public Library Collection.*

63

and the Indian love of "firewater" has been ever noticeable in the Murrays. The Goulds were never addicted to the excessive uses of liquor, while the Pierces and Murrays were more liberal in its indulgence.[53]

Pictures of community life abound in Steward's descriptions. Hog- and beef-killing time in the fall. Pickling the beeves and salting the hogs. Cutting firewood, which he refers to as the "chopping frolic," along with apple cuttings, quilting, haying and marsh burning.

I have been told that these wood choppers would vie with each other to be first at the chopping in the woods in the morning and often, by noon, long tiers of wood would be ranked up and the laughing choppers would wend their way to the homestead where a substantial dinner would await them. In such cases, the afternoon would be given over to sport and "waiting on the women."[54]

Today, Gouldtown transcends color and distinction. As part of Greater Bridgeton, it is simply another community in an evolving area of Southern New Jersey. It is a standing example of the strength brought on by a sense of community, as well as the sense of pride in family and history that sustains us all in times of need. Though no longer an anomaly, Gouldtown remains unique.

Chapter 5

Devils and Angels

If the practice of this Society of which Mr. Dalby speaks, is not discountenanced, none of those whose misfortune it is to have slaves as attendants, will visit the city if they can possibly avoid it.
—George Washington, 1786

U nlike its more genteel neighbor, East Jersey, in West Jersey there came to be opposition to the institution of slavery, not just the mistreatment of blacks and others under bonded servitude. It is important to understand that political and philosophical evolution in this part of Jersey in order to understand the unique working relationship between fringe communities of color and the mainstream Quaker settlements.

DAWN OF A TROUBLED NATIONAL CONSCIENCE

Early on, Quakers Anthony Benezet and Benjamin Lay preached abolition and challenged their fellow Quakers to emancipate their slaves. Anthony Benezet was born in Saint-Quentin, France, on January 31, 1713. His family were Huguenots. Because of the persecution of Protestants after the revocation of the Edict of Nantes in 1685, his family decided to leave France. In 1727, Benezet joined the Religious Society of Friends. In 1731, the Benezet family immigrated to Philadelphia, Pennsylvania, in North America.[55] At that point, he began his work in the Society of Friends and wrote numerous tracts urging his fellow members to eliminate slavery from their lives.

Antislavery sentiment emerged early among the Quakers. Pamphlets opposing the institution were written by members of the religion in Pennsylvania and New Jersey in the late 1600s and early 1700s. George Keith wrote one in 1694, and this was followed by works of Ralph Sanford (1729),

Benjamin Lay (1737) and John Woolman (1754). By the yearly meeting of 1775, the Quakers passed a resolution excluding any Quaker who still owned slaves from the Society.[56]

Benjamin Lay was a crusty, odd, diminutive character, right out of Charles Dickens or Victor Hugo. He ranted against slavery in the manner of the old prophets. He thought that it was a "Hellish practice" and a "filthy sin...the greatest sin in the world, of the very nature of Hell itself, and is the Belly of Hell," and he reprimanded all Quaker slave owners.[57] Most ignored him, calling him a miscreant and blustering fool.

John Woolman was a young merchant's apprentice in Mount Holly in 1743. His employer, and many among the Society of Friends, owned slaves (both black and white). John was accustomed to this situation, though not comfortable with it, and was familiar with the preaching of both Benezet and Lay. He hoped to privately maintain his own principles in the midst of slavery, but he succumbed to reality one day.

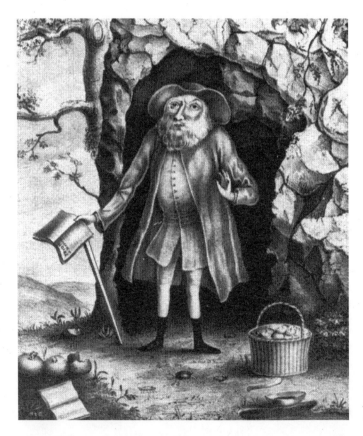

Benjamin Lay.
New York Public Library Collection.

Devils and Angels

My employer, having a Negro woman, sold her, and desired me to write a bill of sale, the man being waiting who bought her. The thing was sudden; and though I felt uneasy at the thoughts of writing an instrument of slavery for one of my fellow-creatures, yet I remembered that I was hired by the year, that it was my master who directed me to do it, and that it was an elderly man, a member of our Society, who bought her; so through weakness I gave way, and wrote it; but at the executing of it I was so afflicted in my mind, that I said before my master and the Friend that I believed slave-keeping to be a practice inconsistent with the Christian religion. This, in some degree, abated my uneasiness; yet as often as I reflected seriously upon it I thought I should have been clearer if I had desired to be excused from it, as a thing against my conscience; for such it was.[58]

John determined that it was not possible for a rational human being to reconcile keeping fellow human beings in bound servitude with the precepts of community and freedom espoused by the Society. His subsequent efforts preaching throughout New Jersey and into the Southern colonies simply reinforced his determination to effect change, at least within his own community of Friends. His efforts were successful in driving a wedge between those members who owned slaves and those who did not, resulting in the eventual determination by the late part of the eighteenth century that slave ownership was a cause for expulsion from the Society.

In the year 1763, John Woolman, in a typical gesture, sponsored the marriage by extraordinary Friends Ceremony of a noted ex-slave, William Boen, to a servant girl, Dido. It was one of numerous weddings on the site of the Burr household of Peachfield Manor, Westampton Township, and one of several formalized ceremonies sponsored by Woolman and other Quakers for free and manumitted blacks that took place prior to the Society actually assisting them in escaping and hiding.[59]

Slavery (black, white and Indian) was a legal institution in all of the thirteen American colonies. A majority of the founding fathers owned slaves, including the author of the Declaration of Independence, the father of the Constitution and the commander of the Continental army. In the seventeenth and eighteenth centuries, slavery was almost as extensive in New York and New Jersey as in South Carolina and Georgia. In a letter to John Francis Mercer, George Washington wrote of his own ambivalence about slaveholding:

Mount Vernon, September 9, 1786...With respect to the first, I never mean (unless some particular circumstance should compel me to it) to

possess another slave by purchase; it being among my first wishes to see some plan adopted, by which slavery in this country may be abolished by slow, sure, and imperceptible degrees.[60]

These "slow, sure and imperceptible degrees" by which George Washington hoped to see an end to slavery were impractical in a society that still did not agree on the status of people of varying backgrounds. The concept of place of birth was still inherent in the identity of the American citizen. One was English, or Dutch, or "of French ancestry," etc. One's place of birth and race defined one's status within the society at large. Even in his two terms as the first president of the United States, Washington was patently unable to directly address the issue of slavery. As John Woolman had predicted almost a century before it happened, the wrenching of slavery from the soul of the country would require a debilitating civil war, in which more than 200,000 blacks participated as soldiers for the Union cause.

These are the souls for whom Christ died, and for our conduct towards them we must answer before Him who is no respecter of persons. They who know the only true God, and Jesus Christ whom he hath sent, and are thus acquainted with the merciful, benevolent, gospel spirit, will therein perceive that the indignation of God is kindled against oppression and cruelty, and in beholding the great distress of so numerous a people will find cause for mourning.[61]

The presence of slaves in New Jersey was not new. Slavery was encouraged in New Jersey under the proprietor's "Concessions and Agreement" in 1664, which offered sixty acres of land for every enslaved African imported. The following year, the agreement offered forty-five acres for each imported African, and, in 1666, it gave thirty acres for every imported enslaved African.[62] The expediency of building a commercially successful colony overshadowed any legal or social conscience regarding the use of slave labor.

In 1702, the two Jerseys united, and England's Queen Anne encouraged commerce in the African slave trade, allowing each colony to set its own import fees. Nearly all other states imposed a serious tax on the importation of men, women and children from Africa to be used as slave labor. Because New Jersey allowed duty-free importation of African people, the colony of New Jersey became the conduit to other states. Slave auctions were moved from Philadelphia (where it was now too costly) to West Jersey at Camden (Cooper's Ferry).

In 1726, there were 2,581 African people counted as slaves in New Jersey. By 1790, there were 14,185, composing nearly 8 percent of New Jersey's population, most held in East Jersey.[63] There were also large numbers of free blacks and many interrelated peoples from among the Lenape, Nanticoke, black and white populations. These peoples formed small communities for personal and economic security, especially in light of the fact that federal law continued to presume a person of color was a slave, unless proven otherwise, into the first decades of the nineteenth century.[64]

SLAVE OR FREE: PARALLEL LIVES UNDER THE SLAVE LAWS

The end of slavery in New Jersey did not even begin to take place until 1804, with passage of an Act for the Gradual Abolition of Slavery,[65] which provided for eventual manumission of the children of slaves owned in the state. This act of the New Jersey state legislature left a large proportion of supposedly free persons subject to economic and social indenture with their existing masters until they attained the age of emancipation (twenty-five for women, twenty-eight for men). It also left many in the intolerable

Greenwich Friends Meeting, Greenwich, New Jersey, circa 1939. *Library of Congress, American Building Survey.*

circumstance of being illegally "sold South" so their owners could profit from them prior to their becoming free by law. The lure of safety within small, isolated communities would have been great.

That there was an early, active effort to assist and encourage runaways in the area of Philadelphia and Southern New Jersey is evident. In two letters, written in 1786, George Washington pointed out the existence of systematic attempts to aid and protect fugitive slaves in western New Jersey and Pennsylvania. Washington wrote that it was not easy to capture fugitives "where there are numbers who would rather facilitate the escape of slaves than apprehend them when runaways."[66]

It is entirely possible that the statement attributed to Washington was in response to the concerns of Mr. Dalby about being able to retrieve runaways in the land of the Quakers. Philip Dalby wrote to enlist Washington's support in recovering a slave. While visiting in Philadelphia, Dalby's servant had been lured away by a group of Quakers organized for the purpose of freeing slaves brought to that city. Dalby inserted a long notice in the Alexandria newspaper warning the general public of this "insidious" practice of the Quakers and declaring that he was, at this time, going to Philadelphia to petition the Pennsylvania assembly for the return of his property. Washington wrote to Robert Morris:

> *I give you the trouble of this letter at the instance of Mr. Dalby of Alexandria; who is called to Philadelphia to attend…a lawsuit respecting a slave of his, which a Society of Quakers in the city (formed for such purposes) have attempted to liberate…from Mr. Dalby's state of the matter, it should seem that this Society is not only acting repugnant to justice so far as it concerns strangers, but, in my opinion, extremely impolitickly* [sic] *with respect to the State* [of Pennsylvania].[67]

If one had to pick an act that marked the beginning of proactive subversion of slavery, most would point to an incident in 1786, when Philadelphia Quakers assisted a group of refugees from Virginia to escape to freedom. This incident would cause the above letter, and George Washington's expression of doubt about a slave owner's ability to recover slaves who managed to reach the boundaries of Pennsylvania and South Jersey.[68]

Different periods are represented by the figures in the accompanying collage. However, all played pivotal roles in sustaining and supporting the movement of fugitives from Virginia, Delaware and Maryland into and through New Jersey.

Harriet Tubman (often called Moses) is credited with directly assisting about fifty escaping slaves from Maryland and Delaware to Philadelphia.

Devils and Angels

Four stalwarts. Though Isaac Hopper was from a different time, his philosophy and determination were implanted in these other three leaders of the Underground Railroad in the New Jersey and Philadelphia sector: Harriet Tubman, Thomas Garrett and William Still. *Composite by author from New York Public Library Collection.*

Almost as important as her deeds was her legend, which encouraged the independent action of others. Her routes varied, and her methods were stealth determination and absolute obedience from her wards. She worked for a time in Cape May to gain funds to pay for her trips South. She went on to become a nurse in the Civil War and lived on to an old age in Auburn, New York.

Thomas Garret is noted to have been one of the most prolific and effective station masters in the Underground Railroad in the East. A Delaware Quaker, he personally assisted, hid and funded several hundreds of escaping persons. He was a staunch ally of the Philadelphia Vigilance Committee and William Still.

William Still, secretary of the Philadelphia Vigilance Committee, personally managed the affairs of many of those arriving in the city from the South. His efforts included hiding, directing, funding and organizing the routes and safe houses around the city, in New Jersey and farther up the routes heading North.

Isaac T. Hopper (1771–1852) is among the first credited with establishing a systemic method for concealing and moving escaped slaves through Pennsylvania and at least as far as New York State. He is also credited with the development of a proactive effort on the part of some Quakers to encourage slaves of visiting persons to escape while in the city.

In 1787, a year after the initial assistance to bondsmen from the Philadelphia Quaker community, Hopper, a teenager, began to organize a system for aiding fugitive slaves. Within a decade (1793), the first national Fugitive Slave Law was enacted. In direct rebellion to it, several towns in Pennsylvania and New Jersey formed vigilance committees to offer covert assistance to bondsmen.

Certainly Hopper, an early progenitor of aid to self-emancipating slaves, was working by this time to support these vigilance committees in their efforts to assist runaways and escort them out of the city to safer havens. Northern Quakers had, by 1786–90, substantially eliminated the holding of slaves among members of the Society, and some were actively aiding in escapes.[69] Among the anecdotes told of Hopper, the following (without date) refers to David Maps and his wife, the only colored members of the Philadelphia Yearly Meeting:

Congress Hall, Philadelphia. It was here, during its initial sessions in 1793, that Congress passed the first federal act to regulate the sale and trading of African slaves. *Author's photo.*

On the occasion of the annual gathering in Philadelphia they [the Maps]
*came with other members of the Society to share the hospitality of his (i.e.
Isaac T. Hopper's) house. A question arose in the family whether Friends
of white complexion would object to eating with them. "Leave that to me,"
said the master of the household. Accordingly when the time arrived, he
announced it thus: "Friends, dinner is now ready. David Maps and his
wife will come with me; and as I like to have all accommodated, those who
object to dining with them can wait till they have done." The guests smiled,
and all seated themselves at the table.*[70]

The infant federal government, operating in Philadelphia, passed
legislation in 1793 ending the legal slave trade from Africa to the United
States. It was a compromise between the slave-dependent South and the
increasingly abolitionist North. This act did not end slavery, only the
selling of slaves brought from Africa. Slavery simply moved into a new
phase—interstate commerce.

This led to two distinctly polar and underground operations in the new
nation. The 1793 Fugitive Slave Act allowed for a greater visibility among the
Quaker and Presbyterian groups fighting to abolish slavery altogether, and
their acts of resistance increased over the following two decades. The law
also allowed for the redress of slave owners to federal courts for the return of
their property. This, in turn, initiated a new and profitable business: catching
and returning escaped slaves.

WHERE AM I FROM, MOMMA?

The 1793 Fugitive Slave Act fueled a huge and vastly profitable underground
industry that took full advantage of the inferior legal status of free and enslaved
blacks. The law allowed state legislation to stand that considered any black (or
colored) person a slave unless that person could prove otherwise. The law made
it possible for a white person to claim any black person as a fugitive, and it placed
the burden of proof on the captive. Free blacks living in Philadelphia, Cincinnati
and other cities near the borders of slave states were especially vulnerable,
though several well-known cases demonstrate that no state was immune.[71]

Under the revised statutes of the late eighteenth and early nineteenth
centuries, in which any person of color was presumed a slave unless he or
she could prove otherwise, kidnapping became rampant and profitable.
Once "sold South," it was near impossible for a person to find his or her way
back home to friends and family.

"Kidnapping" by George Bourne, one of the founders of the American Anti-Slavery Society and also the editor of various publications dealing with antislavery and poperism, most notably the *Christian Intelligencer. New York Public Library Collection.*

Slave speculators (or slavers)—who legally purchased the rights to runaways, captured them, and then resold them at a profit—often seized blacks at random, banking on their inability to prove their status to the satisfaction of a magistrate. A kidnapping ring discovered to be operating in and near Philadelphia in the mid-1820s provided evidence of how similar rings functioned. With relatives and a mulatto man as accomplices, Joseph Johnson preyed on children between the ages of eight and fifteen, luring them onto a ship with promises of work, then transporting them south and selling them into slavery.

Children provided a low-risk target, even if their cases somehow attracted legal intervention. Dramatic changes in children, resulting from growth and physical abuse, made indisputable identification difficult even for relatives—whose testimony would not have been allowed in any case—much less for a white patron, who would have to bear the expense of traveling South to make the identification. In a two-year period, at least a hundred black children were abducted from Philadelphia alone.[72]

Identifying family trees and histories has become an important part of understanding the background of many people of color in the United

States today. It is important to appreciate that the cohesion of community found within the isolate towns became the basis for generations of "family," even though there may have been little to genetically connect the various members of that family. Extended families often consisted of cousins and distant relatives, as well as unrelated, adopted members who were seen as aunts, uncles or alternative mothers and fathers. The following narrative of Moses Grandy requires no interpretation:

> *I do not know where any of my other four children are, nor whether they be dead or alive. It will be very difficult to find them out; for the names of slaves are commonly changed with every change of master: they usually bear the name of the master to whom they belong at the time. They have no family name of their own by which they can be traced. Owing to this circumstance, and their ignorance of reading and writing, to which they are compelled by law, all trace between parents and their children who are separated from them in childhood, is lost in a few years. When, therefore, a child is sold away from its mother, she feels that she is parting from it for ever: there is little likelihood of her ever knowing what of good or evil befalls it. The way of finding out a friend or relative, who has been sold away for any length of time, or to any great distance, is to trace him, if possible, to one master after another; or if that cannot be done, to inquire about the neighborhood where he is supposed to be, until some one is found who can tell that such a person belonged to such or such a master: and the person supposed to be the one sought for, may perhaps remember the names of the persons to whom his father and mother belonged. There is little to be learnt from his appearance, for so many years may have passed away, that he may have grown out of the memory of his parents, or his nearest relations. There are thus no lasting family ties to bind relations together, not even the nearest, and this aggravates their distress when they are sold from each other. I have little hope of finding my four children again.*[73]

Peter Still is a case in point. Peter and his brother were kidnapped from his master's farm as young children (see chapter 6). They were "sold south" to overseers in Kentucky and Alabama by the slaver who enticed them into his carriage. Forty years later, Peter escaped and went to Philadelphia, where he was taken in and provided aid by the secretary of the Vigilance Committee in that city. That person was William Still, his brother, who had not yet been born when Peter was kidnapped.[74]

According to James Oliver Horton:

When fugitives did strike out for freedom, their destinations varied, depending on their starting point. In the lower South, Mexico (which abolished slavery in 1829) offered a tempting haven, as did Native American areas in Florida, present-day Oklahoma and elsewhere. For port towns along the Mississippi or on the Atlantic coast, black sailors and river men became legendary for their willingness to assist fugitives who might stow away on vessels bound for the North, Latin America, Europe, or other freedom ports. Slaves held in the upper South—in Kentucky just across the Ohio River from the freedom of Ohio or in Maryland or northern Virginia within a few days travel of Pennsylvania—had the best opportunity for escape to the northern states where they could often find aid from the organized underground railroad groups that have become a part of American folklore.[75]

The Greenwich Line was one of the escape routes. It began in the hamlet of Springtown, led twenty-five miles north to Small Gloucester and continued north to Mount Holly, Burlington and Jersey City. The communities along this route were ideal stations on the Underground Railroad as they were situated less than twenty miles apart, surrounded by Quaker land that was often swamp or dense woods and was inhabited by many free African Americans.[76]

Another escape route often mentioned is from Cape May (or Cold Springs) through the site of present-day Millville to Snow Hill and thence to Haddonfield. Another (according to W.J. Switala and others) is from the Cape May area, through what is now Kresson, Blackwood and to Snow Hill or Camden.[77] W.H. Siebert describes a route from the Greenwich-Springtown area, probably through Salem and Sharptown (Marshalltown), to Swedesboro. The AME church in Springtown, and that in Swedesboro (Dutchtown), were critical way stations in this route's success.[78]

The support provided by the small, isolated communities along this route cannot be underestimated. A parallel might be seen in services provided to fallen Allied aviators during the Second World War by the French Underground—assistance, aid, food and transport to a friendly zone. Similarly, those escaping Jews during the same period, who were hidden by friendly gentiles and provided with false passports, clothes, food and money, would have had a lot in common with the escaping slaves passing through these small communities. These were far more than simple enclaves of bumpkin farmers and mechanics working for the surrounding plantations and businesses. These were true safe havens and a necessary resource for

a new start in life. In a way, these could be considered rural ghettos, in the original sense of that word.

AN ASSEMBLY OF NECESSITY

As noted, the great migration of peoples into Southern New Jersey during the 1600s and 1700s resulted in a great deal of cultural, economic and physical cross-pollination. Dutch and Swedish immigrants had merged in the face of the English claims, and the Europeans had banded together in dealings with blacks and Indians. Indians and free blacks had banded together with some whites to form small communities, separate from, but interrelated with, the larger white communities.

Small, isolated communities sprang up in response to the need for social cohesion and mutual aid. In a sense, these could be considered rural ghettos.

> *No other northern state exceeded New Jersey in the number of all-black communities that served as Underground Railroad sanctuaries for southern fugitive slaves. Springtown (Cumberland County), Marshalltown (Salem County), Snow Hill (present-day Lawnside, Camden County), and Timbuctoo (Burlington County) were among such places, located mainly in rural South Jersey, in which fugitive slaves also settled. One consideration for remaining in these communities was the physical safety they afforded runaway slaves; there are several instances recorded of slave catchers being run out of town with haste.*[79]

Preachers used the venue of the African Methodist, Baptist and Presbyterian churches where possible. Farther south, African Episcopal congregations gained favor. Camp meetings and exhortations by visiting preachers were well attended by blacks and whites alike. Female preachers, like Jarena Lee and Maria Stewart, held camp meetings and "exhorted" throughout the Eastern Shore of Maryland and Delaware during the early decades of the nineteenth century. As Kate Clifford Larson notes:

> *The rise in evangelicalism and its concentration on spiritual freedom, particularly in the early to mid nineteenth century, had potentially troubling consequences for slaveholder's interests. Slaves' access to religious instruction depended upon individual slaveholders, but it was generally allowed on the Eastern Shore of Maryland.*[80]

Lee, Stewart and Zilpha Elaw spoke frequently at such services and meetings, risking both arrest and sale into slavery under contemporary law. Larson believes it likely that their passion inspired one of the more well-known heroines in this epic, Harriet Tubman, who grew up and lived in this same area. Later, she would indicate that her efforts to retrieve enslaved blacks from the South was a crusade, given her by the same God that moved Elaw, Stewart and Lee.[81] Larson writes:

> *On the cusp of adulthood, the disabled Tubman went to work on a timber gang, exhibiting great skills in laboring in the logging camps and in the fields. There she was exposed to the secret communications networks that were the province of black watermen and other free and enslaved blacks… Tubman's life revolved around the farms and small cabins in the black community while she labored for larger landholders and farmers… The free black men who toiled next to their enslaved friends were able to move about freely, from one community to another, from one family to another. These black men were part of a larger world…that reached to towns and cities up and down the Chesapeake, ranging as far away as Delaware, Pennsylvania and New Jersey. They knew the safe places, they knew the sympathetic whites, and…they created a veiled and secret world parallel to the white master's world.*[82]

In October 1849, about two dozen slaves escaped in Talbot County (Maryland). In the notice of the escape, in which many were said to have been recaptured, several were noted to have "successfully made their way south east, across Caroline County [Maryland] to the Delaware Bay shore, and thence to New Jersey."[83] In William Still's records of the runaways arriving at his door in Philadelphia, he makes note of "Moses" and her toil at leading people out of the land of slavery.

The path taken by many, including Harriet Tubman, most often went directly from the Delaware or Maryland land border with Pennsylvania to Philadelphia. From there, the route led across the river to Camden or up the western side of the Delaware to points near Allentown, Pennsylvania, and Binghamton, New York.

Tubman's work took energy, drive and funds. Much was gained from the likes of Thomas Garrett, who helped hundreds, if not thousands. Harriet notes in her dialogue that she worked for several summers at the South Jersey resort town of Cape May. Here, to earn money for her travels, she cleaned rooms, waited tables and took on even heavier work if that was what paid. Emma Trusty notes that federal census and local

tax records show her as "hotel cook,"[84] which would have been seasonal employment, much as the Jersey Shore employs thousands during the summer today.

In traveling between Cape May and Philadelphia, she needed to course through the very towns we are discussing; her familiarity with them and their resources for escaped slaves should not be doubted, though her presence in this area may have been limited. Of interest here is that Thomas Garrett may have worked very closely with J.R. Sheppard of Greenwich in this endeavor—thus adding substance to the use of the cross-Delaware route by many more refugees than previously estimated.[85]

A black farmstead photo. Small farms were able to provide some subsistence, though the owners needed to supplement their crops with seasonal employment. This probably would have been the image seen in any of the small towns we are discussing. *In Norman Yetman,* Voices From Slavery, *2000.*

Once in New Jersey, fugitive slaves found white abolitionists and free blacks in no fewer than thirty-eight towns and settlements in nineteen counties ready to assist them. They were willing to guide the fugitives along strange and sometimes dangerous roads or provide shelter, food, clothing, shoes or traveling money. Many of the abolitionists were Quakers.[86] According to the National Park Service:

> One of the most successful Underground routes in southern New Jersey led from Delaware Bay across Cumberland County through Woodbury and Westville in Gloucester County, Gloucester City and Camden in Camden County, south from Medford through Mt. Holly. Trenton was an important stop on the Underground Railroad for fugitive slaves on a route from Philadelphia that led into Staten Island. From Trenton, another connection of the invisible train led overland into Jersey City, Newark, and finally New York City.[87]

The existence of free persons of color, even in the Southern colonies, is a point not often made in traditional histories. The evolution of a parallel existence, using those components from the larger society that were necessary to maintain freedom and personal safety, has been a fact of life for centuries. The attempt of the larger, white community to continue the repression of the community of color throughout American history takes several forms; some are relatively benign, most are dehumanizing and many are outright evil.

Each of the communities presented arose under different circumstances and for differing reasons. Each, however, gives an example of the central theme of this discussion; it was an alternative founded to provide succor and a sense of community for people who were essential to, but still outcasts within, the predominant white society. Slavery in the New World, relocation of the indigenous tribes, blatant discrimination against all persons of color, immigration fueled by indenture and child labor all contributed to establishing groups that were in, but not of, the larger society.

Chapter 6
Springtown

I was born on the 17th October, 1817, in that part of the State of Maryland, commonly called the Eastern Shore. My parents were slaves. I was born a slave. They escaped, and took their then only child with them. My father had a cousin, in New Jersey, who had escaped from slavery.[88]

—*S.R. Ward*

Samuel Ringgold Ward became a prominent preacher and abolitionist in New York State. Running from slavery with his father and mother, he first came to a small community of free blacks and secreted former slaves. Samuel was three years old. For several years, he called home this small community known as Springtown, near Greenwich, New Jersey. (I have been cautioned that the town is pronounced "Green-Witch," not "Grenitch" as with the unrelated town in Connecticut.)

On County Route 607, being the extension of Ye Greate Street in Greenwich, lies a crossroads that could easily have been the impetus for Robert Johnson's blues tune of the same name. Johnson's crossroads is in Mississippi, but the juncture of Sheppard's Mill Road and Springtown Road serves equally well as the point from which to reflect on the colored community of Springtown. "Colored" in the same sense as Gouldtown, being a haven for a diverse group of free blacks, escaped slaves and others; interrelated Indian, black and white families. Ward recalls:

After his escape, my father learned to read, so that he could enjoy the priceless privilege of searching the Scriptures. Supporting himself by his trade as a house painter, or whatever else offered, he lived in Cumberland County, New Jersey, from 1820 until 1826.

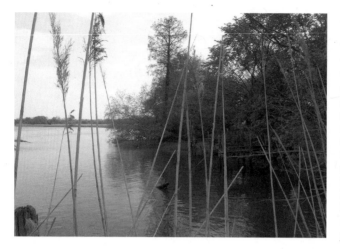

Cohansey River from Sheppard's Landing. The entrance to the river is covered with marsh- and swampland, as well as large swaths of salt grass, cattails, flax and reeds, as are most of its tributaries. Today, after years of foundering ships and lost mariners, there is a lighthouse at the entrance. *Author's photo.*

In her book, *Reminiscences of Greenwich*, Bessie Ayres Andrews writes:

> *The fugitive came by boat from Dover* [Delaware] *and other points; boats with colored lights—said to be yellow and blue—were manned with watchers, and the slaves exchanged to Greenwich boats and conveyed to the village; they were then forwarded to Swedesboro and Mount Holly; thence to Burlington and Jersey City. Some of them were hidden for days in the colored settlement at Springtown, while some remained for life.*

GREENWICH

Greenwich is located but a few miles up the Cohansey River from Delaware Bay. Across the river lies the township of Fairfield (Fairton), which was connected to Greenwich by ferry in the old days. No discussion of Springtown can take place without a corresponding review of Greenwich and the area known as Bacon's Neck. In her book, *Grandfather's Farm*, Mary Patterson Moore writes:

> *The first thing I recollect when on a visit to Grandfather is Aunt Rachel taking me to see the men burning the marsh. The whole scene is vividly present to me now; it must have been seventy-seven years ago, 1782, at least. I thought it the most beautiful site I ever beheld…The flames spread over a large surface for miles along the shore and the sky was beautifully lighted up while a number of men with their rakes and forks…were dark objects between us and the fire.*

82

Springtown

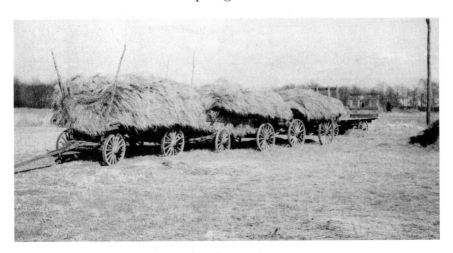

Salt hay wagons loaded for transport. *From J.S. Sickler,* History of Salem County, *1950.*

Salt hay is a natural grass that grows in abundance in the swamps and creek beds of Southern New Jersey. In the early days, and even today, it was used as cattle feed and for all the other purposes farmers use regular hay. It contained salt from the brackish water and so fulfilled the need of the animals for salt, as well as greens. Harvesting this naturally occurring crop was easier than sowing fields with traditional hay, leaving space for other crops. Later on, the tough hay was used to pack glass as well as for animal feed.

According to the National Park Service:

> *Salt hay farmers followed the tradition of their parents and grandparents who began the salt hay harvest in late June or early July and continued well into the winter months, or until all the hay was cut. The best grades were cut before the first frost. Prior to mechanization, some farmers stacked portions of the crop in the meadow and waited for the marsh to freeze before safely bringing the horses and sleds or wagons out onto the meadow to retrieve the hay. The swampier parts of the meadow were cut in the winter time, too. In late March or early April, depending upon the dryness of the marsh, farmers burned the meadows, which helped produce a clearer and brighter grass. Burning also prevented tracts of meadow that had not been cut for several years from becoming boggy. Today, farmers rarely burn the meadow, but it is still considered a means of producing a better crop and controlling the growth of phragmites, a worthless marsh plant that chokes out the salt hay.[89]*

Wood's Store, Greenwich, is typical of the architecture in this colonial town. Greenwich is noted as a stopping point for some of the runaways as they prepared to move to Springtown or farther North. *Author's photo.*

Wood home, circa 1795, Greenwich. *Author's photo.*

Springtown

Greenwich was the second formal site established in Fenwick's Colony, West Jersey. It was one of the official ports of entry into the British colony prior to the American Revolution, and it kept a role as a port of entry and shipping town for decades after. The village provides a prominent benchmark for South Jersey history and restoration, being largely preserved and intact from the late colonial period. It holds dear the memory that its citizens hosted the only other "tea party" outside of Boston to protest the taxes on that product. Many of the buildings date from before the Revolution, with alterations and additions changing their images only a little. A fervent mandate maintains the historical district intact these days. The Cumberland County Historical Society, headquartered here, is a marvelous resource for anyone seeking information on the area.

W.J. Switala notes:

> *The salt marshes and creeks of southern New Jersey crisscross that portion of the state. Until the late nineteenth century, most were impassable except by boat; few, if any, were crossed by bridges. This established a very clear pattern of routine travel for most people, including fugitive slaves and their pursuers.*
>
> *The Atlantic Coastal Plain extends southward from a line drawn between Trenton and Newark. To the Northwest of this line is a piedmont plateau, which gives way to a series of ridges and valleys that extend from Pennsylvania.*

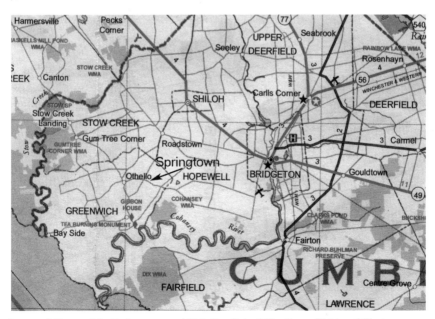

A map of Greenwich, Springtown and Othello. *State of New Jersey, Division of Tourism.*

Because New Jersey is almost surrounded by water, it has numerous rivers that flow into the Delaware River and Bay, Atlantic Ocean, and Hudson River. These waterways provided a natural highway over which fugitive slaves could enter the state from Delaware or points farther south and west as they continued their journey to freedom in the North. There are numerous tales of fugitives coming from Delaware or points farther south and crossing the Delaware River and Bay in a wide variety of watercraft.[90]

SPRINGTOWN—OTHELLO

Located along the road to Sheppard's Mill, there is an ongoing debate as to how the town came to be called Springtown. Some believe there was an original settler with the surname "Springer," who was a prominent founder of the village. Others feel it was because of the various springs located in the vicinity. The Works Progress Administration's *Tours of New Jersey* offers the following, which is more accurate than most of the tourism descriptions:

SPRINGTOWN, 3.8 m. (30 alt.), together with the neighboring hamlet of OTHELLO (R), has been a Negro settlement for more than a century. Amateur architecture and carpentry prevail in the small, weather-beaten, unpainted homes. The small wooden school and still smaller church at the crossroads are the only buildings that bear evidence of continued use. Each house is surrounded by fields where farming is intermittently attempted. The residents are practically all workers on the nearby farms. It was a station on the Underground Railroad during slave days.[91]

Jacob Bryant was the principal settler of the area that would become Springtown. Early Greenwich Township stretched through what is now Bacon's Neck, Stow Creek, etc. Fairton, home to Gouldtown, was on the other side of the Cohansey River. It was settled by New England dissenters early on (pre-Revolution)—I guess we could call them "less pure" Puritans than those at Plymouth.

In 2008, Laura Aldrich noted:

Jacob Bryant, grandfather of John Bryant, my ancestor, bought property in Greenwich Twp Dec 17, 1802 for $101 from Jonathan Wood. He and his wife Elizabeth had at least 5 children. According to Abel Bryant (my cousin) Jacob (c1775) came to Greenwich Twp from Colonial New

Springtown

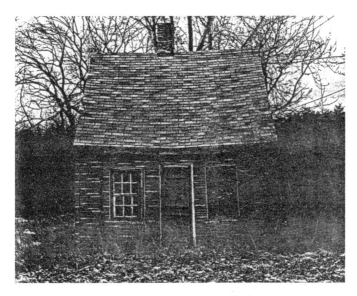

Robinson House, Springtown. This house was photographed by Maria Boynton in the late 1980s. It is a prime example of the early homes of the residents in this crossroads town. It also bears strong resemblance in style and size with many of the homes in the small towns we are discussing (see Murray home, Gouldtown and the next illustration). The Robinson House no longer stands. *Photo by Maria Boynton.*

A Springtown house. The consistency of this housing style is uncanny in South Jersey. There is also reference to this style in small black communities in Georgia. It is not a "shotgun" house, but it appears to be a variation on old slave quarters and log cabins. *Author's photo.*

England after the Revolutionary War. I have not been able to document this, but a lot of other information he told me was true.

That a soldier from Rhode Island or Massachusetts would move here would be very possible—and there were two all-black regiments in the Revolution, one being the First Rhode Island. Connections through servants to the group of settlers at New England Crossroads (Fairton) would be probable, and that regiment had passed nearby during several of the battles in the area, including the one at Red Bank, not a dozen miles distant.

Samuel Ward's family made it to Springtown from slavery in 1820, as did Levi and Charity Still. Both found refuge in Springtown, as Samuel relates:

They found, as they had been told, that at Springtown, and Bridgetown, and other places, there were numerous colored people; that the Quakers in that region were truly, practically friendly, "not loving in word and tongue," but in deed and truth; and that there were no slaveholders in that part of the State, and when slave-catchers came prowling about the Quakers threw all manner of peaceful obstacles in their way, while the Negroes made it a little too hot for their comfort. Then these attractions of Cumberland were sufficient to determine their course.

We lived several years at Waldron's Landing, in the neighborhood of the Reeves, Woods, Bacons, and Lippincotts, who were among my father's very best friends, and whose children were among my school fellows. However, in the spring and summer of 1826, so numerous and alarming were the

AUTOBIOGRAPHY

of

A FUGITIVE NEGRO:

HIS ANTI-SLAVERY LABOURS

IN THE

UNITED STATES, CANADA, & ENGLAND.

BY

SAMUEL RINGGOLD WARD,

TORONTO.

NEW YORK
PUBLIC
LIBRARY

JOHN SNOW, 35, PATERNOSTER ROW.

1855.

Samuel Ringgold Ward and the cover page to his story. *New York Public Library Collection.*

depredations of kidnapping and slave-catching in the neighborhood, that my parents, after keeping the house armed night after night, determined to remove to a place of greater distance and greater safety.[92]

A critical piece of information in this statement is in the first sentence: "as they had been told." Communication between free blacks and slaves, between Quakers and slaves, between and among slaves on adjoining plantations, allowed for the dissemination of information about the North. Free black boatmen and stevedores helped slaves and their families aboard ships bound for Philadelphia and other ports. Itinerant preachers told stories about the North, where one could own land and make a living. They told about those small towns, like Springtown, where others had gone before.[93]

Ambury Hill Cemetery

This parcel of land is where the Othello and Springtown communities got their start. It is located about a mile from the spot known as "Head-of-Greenwich," the intersection of present-day County Routes 650 and 673. Jacob Bryant, the former soldier from Massachusetts, and Charles Lockerman purchased Ambury Hill in 1810 from Quaker Thomas Maskell. The price was $100.

Buried in this plot are founding members of the community: Charles Bryant, Maria Clark, Julia and Algea Stanford, Old Blind Jake, Benjamin

Ambury Hill Cemetery. The hill was where the original church building was located; the church was burned down twice by arson. *Author's photo.*

Clark and others. Algea Stanford was one of those who manned the oars on the boats bringing escaped slaves to shore in this area, and he was a well-known participant in aiding runaways. Bessie Andrews recalls the processions of people when there was a funeral:

> *If we children could catch a view of a precession slowly winding up the hill from this shop room window* [at Head of Greenwich] *our play was suspended, a quick exit made and a hasty run up the hill, by the quarry, to stand by the fence to observe the closing scene of their obsequies. There was a very old church in this burial ground in 1830, remembered by the residents that were living fifty years ago.*[94]

The black community adopted a vacated building, formerly used as a meeting by the Quakers. After this building was destroyed twice by suspicious fire, they rebuilt a short distance away. The village of Springtown grew up around the second church. This second church, now on the historic register, serves the community to the present day. But the community is not what it was.

Springtown is mentioned in various tomes as a colored community owing its existence to escaped slaves. Whether this was the absolute basis for the settlement situated a few miles from historic Greenwich is questionable, but probable. Reminiscences and diaries tend to present only the writer's point of view. However, those about Springtown tend to concur. The town was in existence at least as early as 1820 and probably earlier. Indication is that

Othello AME Church, Springtown. A building placed on the National Register of Historic Places by the efforts of Laura Aldrich and other parishioners, this church has been a central part of the lives of people in Springtown and vicinity for almost two hundred years. *Author's photo.*

Springtown

Bryant owned one acre of land (taxable) in the area as early as 1802, and by 1812 he had amassed twenty acres. This is a sizable chunk for the time and shows him to be perfectly capable of sustaining and supporting refugees as part of a larger effort.[95]

Sarah Sheppard Hancock wrote a magazine article in 1951, "Memories of Springtown," for *We Women*, a local Cumberland County women's magazine. Her presentation emphasizes the economic beginnings of this village. Sarah talks about Quaker John Sheppard's gristmill at a road junction a few miles from Bridgeton. Aptly named "Sheppards Mill Road," the track runs directly between Springtown and Head-of-Greenwich (where "ye Greate Street" begins). Traveling it today, one can drive past the still-standing, large plantation house and miss the intersection of the Sheppards Mill–Springtown Road altogether.

As Sarah Hancock notes:

> *In addition to the legacy to his sons of land and money, John Sheppard left them the finer heritage of kindly feeling for those in trouble. To his son Benjamin he bequeathed the mill property. Escaping slaves found welcome there. Benjamin owned many acres of land that was mostly dense forest. The soil was sandy, dotted with springs as the water flowed downward underground from Pine Mount. To the men who came to this Quaker for refuge, Benjamin Sheppard offered an acre of ground if they would cut the trees and erect upon the land cabins for their homes. Many took advantage of the offer.*[96]

Maria Boynton suggests this largess of land in return for hard work explains how semi-indigent black people, arriving with very little more than the clothes on their backs and a knowledge of hard work, were able to acquire land and assets.[97] In addition, Boynton indicates that the image of Springtown in the eyes of most Greenwich residents was one of a place that had just always been there, no big deal. Springtown is an archaeological site that has never been properly written up or described. The little houses are different from the other houses around, not only because of their humbleness, but also because of their shape. Boynton feels this shape has some precedence in the Creole homes of Louisiana and possibly Haiti, but more work is needed to determine the origins, which are perhaps even a combination of Swedish/Dutch log cabins and Southern plantation or tenant cabins.[98]

Springtown is remembered through oral tradition and former slave writings as a safe place for slaves who ran away from Maryland and Delaware. Emma Trusty relates that Harriet Tubman lived in the area off

and on over a ten-year period while planning and setting up her "rescues," and she helped run the Greenwich Line of the Underground Railroad.[99] There is no hard evidence of this, and William Still's recollections of her, as well as her own descriptions of her travels during this time, indicate that she took the overland route from Maryland through Delaware and into Pennsylvania.[100] Of course, there is no concrete way of disproving the role of Springtown either.

As noted earlier, escape across the Delaware Bay into New Jersey meant landing in one or another of the tidal creeks dotting the area. Cohansey Creek (or river) was one of those widely used since it was familiar for decades to many boatmen as the principal port of South Jersey. Once across, and connected with supporters on the Jersey side, self-emancipators found a ready haven not three or four miles away.

Louisa Bryant notes:

> *In those* [early] *days the access was not so dangerous, just having to cross the Delaware River. Free people were always armed with their old flintlock muskets, ready to kill and slay their enemies at any time. In fact, Springtown had their watchmen, and every strange white man had to give a good account of himself or leave. Hundreds of our people were "underground."*[101]

Bessie Andrews recalls several of the familiar characters who would visit her uncle's shop and hailed from Springtown or along Bacon's Neck.

Head-of-Greenwich. Sarah Hancock talks about watching processions of black mourners on their way to Ambury Hill burial ground from her uncle's loft in a home like this one. *Author's photo.*

Springtown

A very tall man with a dusky skin and long braided hair occasionally came to the building. He was so very tall and straight we children would scamper when we first saw him, but when we learned his grandmother was a remnant of the Indian tribe we looked upon him with much interest. He braided round shapely baskets and made corn husk mats and brought them here to sell.

Two of the aged colored men who frequented the shop, resting by the log stove in winter, were "runaway slaves from the State of Delaware."

Two of them are indelibly fixed in our memories. The names they were known by were "Old Blake" and "Blind Jacob Jackson." The latter, being almost sightless, was able to husk corn on the farm by being directed by my younger adopted brother.

Old Blake did not know his exact age, but knew he was very old. His principle business was gathering old iron and bringing it into the shop to exchange for a few pennies. He told us what bird we would see in the clear shining following a storm, and we would find it invariably so. He called the storm by the name of the bird. Some of the storms were for the setting of berries; each had a special meaning for him.

Sheppard's Landing (about 1910). Greenwich's primary claim to fame over the years was its "Tea Party." In 1774, a band of stalwart lads arranged to destroy the tea awaiting tariff processing at the dock in Greenwich. This same dock, located near the Quaker Meeting in Greenwich, was the landing site of many runaways making their way across the Delaware to safety in Quaker territory. *Cumberland County Library.*

If we made inquiries of these old men regarding their escape from slavery they would answer in a whisper for fear someone was near that would reveal their whereabouts to the spies or slave catchers that were on the alert.[102]

Two women, Maria Clark and Elisabeth Winrow were known to Bessie Andrews and often related their tales of escape to her. Both remained in Springtown and Bacon's Neck the rest of their lives. Maria related that she was in constant fear of recapture, and she built her log cabin herself, in an isolated section of Bacon's Neck, for fear that laborers would expose her location.[103] Elisabeth was snared by a slave catcher at one point, returned to slavery and escaped a second time to remain in the Springtown area thereafter.

Above all, Springtown was an agricultural community with its feet firmly planted in the tilled soil and its arms gathering the largess from along the Cohansey River. Activity was seasonal, as with any farming community. Shipping and fishing made up where land husbandry left off. The landowners and principal merchants were Quakers. Business was conducted throughout the region, and slavery was not tolerated.

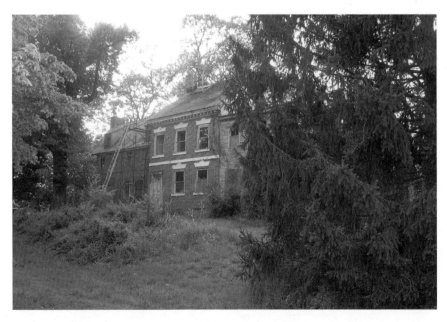

Sheppard's Landing today. In process of restoration, the building lacks only the brick and mortar "keep" seen in the previous illustration. That portion was directly opposite the landing and, when demolished, was noted to have musket ports in the walls for firing at attackers. *Author's photo.*

Chapter 7

Marshalltown and Salem

On or about the 1st of June in the year of 1813, Peter Spencer with his followers, left the church they had built at Ninth and French streets, Wilmington, Del., for the purpose of starting a free and independent church of their own.

—*D.J. Russell*

The lesser-documented communities are as important as any other, but they have elusive resources; less in the way of readily attained information. They are also not as visible as communities discussed in more detail. This might be serendipitous, in the sense that many of these communities bore several names expressly for the purpose of confusing slavers and slave catchers. Thus, Springtown is often listed as "Greenwich," Free Haven as "Snow Hill" and Marshalltown as "Salem" in narratives.

It has been difficult to leave off the in-depth research and investigation of these communities in order to meet the deadline for this book; indeed, to be able to complete the book. As a result, the reader may want to take the pieces of information provided and pursue his or her own interest through the myriad resources still awaiting discovery in this region of the country's most densely populated state. The resources are elusive, but they are there.

FROGTOWN OR MARSHALLTOWN

This community is described in *Place Names of Salem County* as "a colored settlement and church in Mannington on a road from Mannington Causeway to Slape's Corner." On a visit to the area, it was easy to see that Marshalltown was situated perfectly to provide an out-of-the-way hiding place for fugitives and wary free people of color. It was also easy to see where

the name "Frogtown" originated, as several of these creatures scurried about the crumbling asphalt.

The road leading into the settlement loops through swampy terrain, with a tired old sign indicating that it frequently floods. Passing a low section, where the algae-covered water of the swamp touched the edge of the macadam, it was clear that this was an area that would not have been coveted ground. It is also a location that would be easy to defend, considering there is really only one way into the place, and it is surrounded by swamp and the Salem River marshes. According to Jim Turk of the County Historical Commission, there is concern that continually rising tides will shortly inundate this area completely.[104]

Agriculture remains the primary use of the land today, with laborers from a different population providing much of the manpower these days. Tomatoes remain a principal crop, requiring staking and cultivation during the growing period. Throughout the area are reminders of large plantations dating back to the colonial period. Many of these are now just stately homes situated in the middle of commercial and corporate fields, but some remain the homestead farms they once were.

Around the corner, on incongruously named Roosevelt Avenue, is the Mount Zion AUMP Church, which is still in use. (Actually, crossing open fields, it is only about two hundred yards from the decaying school.) The African Union Methodist Protestant Church had beginnings similar to that of the AME Church and served similar congregations.

In 1813, Bishop Peter Spencer and Bishop William Anderson were inspired to lead in organizing the Union Church of African Members. The new

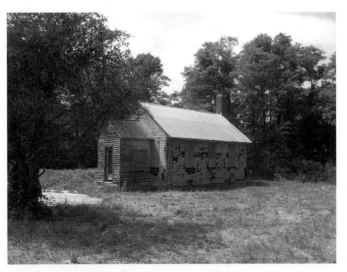

As you come around the bend of Marshalltown Road, watching the frogs and critters scatter through the swampy ground to the right and left of the road, you encounter this building. An old schoolhouse, it is awaiting restoration or relocation. *Author's photo.*

church was born during the peculiar institution of slavery in America. The first African American independently controlled church was incorporated in Dover, Delaware, in September 1813. It soon instituted connectional form with the acquisition of small congregations in New York and Pennsylvania. In 1866, the African Union Church united with the First Colored Methodist Protestant Church. The merger formed the African Union First Colored Methodist Protestant Church of the United States of America, or elsewhere ordinarily known as the African Union Methodist Protestant Church.[105]

On or about June 1, 1813, Peter Spencer, with his followers, left the church they had built at Ninth and French Streets in Wilmington, Delaware, for the purpose of starting a free and independent church of their own. The Mount Zion African Union Methodist Protestant Church, Marshalltown, Salem County, New Jersey, is the mother church of the Philadelphia and New Jersey District and one of the oldest and leading churches in the connection.[106]

D.J. Russell, in his book *History of the African Union Methodist Protestant Church*, writes:

> *Rt. Rev. Isaac Boulden Cooper, D.D., our late general president; Bishop Daniel James Russell, D.D., our present presiding officer of the Philadelphia and New Jersey District; Rev. N.F. Wilson, Sr., that has crossed the swelling flood; Rev. Nathan F. Wilson, Jr., these great men were converted and started on their Christian journey from this historical church.*

Mount Zion AUMP Church, Roosevelt Avenue, Marshalltown. With a congregation still in place, though shrinking, this church remains one of the remote sites of past Underground Railroad activity in the state. *Author's photo.*

Marshalltown House. This home is typical of the small second-generation homes of the area, as opposed to the single-story quarters seen in Springtown and Gouldtown. The family that owned this home was probably well-to-do in the community, compared to their neighbors. *Author's photo*.

The idea that these communities were tightly knit and self-sufficient, according to W.J. Switala and others, calls for tweaking. The small, isolate communities we see in Southern New Jersey were *very* dependent upon seasonal and day work from the surrounding white community. While most people (black, white and Indian) could manage a kitchen garden, few could manage a cash crop of sufficient size to supply for the needs of the household throughout the year. Most people (white, black and Indian) hired out during the winter to cut ice or wood, to log or to serve on oyster boats or cargo barges. Many black women hired into the households of the local white plantation owners and merchants, serving as house servants and laborers.

Marshalltown evolved, with a school, a church and identifiable culture and history. This can be seen in the narratives of the AUMP church, whereby the place exercises great influence on many of the ordained ministers and elders. Only the silent testimony of a lone, unoccupied house across Roosevelt Avenue provides indication of the community that used to be. The narrow "avenue" that serves the church ends abruptly at a sea of flax and swamp water.

THE SALEM CONNECTION

Salem was the first town established by Fenwick upon arriving at his new property in West Jersey. The site of Fort Elfsborg lies just a few minutes' drive toward the Delaware River. The Friends Meeting here is among the oldest in the state, and there are numerous small enclaves. Located along the branches and swamps of the Salem River, these communities were almost exclusively agricultural. They still are.

Marshalltown and Salem

Just outside of Salem proper, on the King's Highway, are a small church and typical single-story homes. When asked, a local kid said it was Clayville. "Better watch out," he said, pointing down the street toward the tall flax and rushes. "There's animals down there." There probably were, but none was encountered this day. However, there was an old home located across the street that was circled by some dogs, which appeared not to have had a very good day to that point. It made one pause to reflect before venturing too close.

Salem was the second location of an African Methodist church given full status in the AME faith after the main church in Philadelphia. The small meetinghouse at Moore's Corner became a gathering place for many free blacks, people of color and others in the area of Salem. It became an official "district" in 1816, serving as one focal point for runaways.

Abigail and Elizabeth Goodwin, sisters whose home is on the Salem tour of historic places, were Quaker and abolitionist sympathizers; they were also avid supporters of refugees. Abigail, in particular, though not wealthy, is noted as having sent funds with runaways to assist them in their travels and having provided support to the various operators in the Salem area in many ways. Both women personified the larger community attitude in the Salem area and have had substantial reports of their activity written over the years. William Still praises them in his book.

Of significance for the role of our settlements near Salem in aiding fugitives is the location of the town along a bay and river (Delaware) that borders Delaware and Maryland, both slave states. Of equal significance in the location of Marshalltown is the wide expanse of the Salem River and

The view across the Delaware from the original site of Fort Elfsborg, New Jersey. Pea Patch Island is seen in the foreground; the Delaware shoreline is in the background. About two miles wide at this point, the river is certainly navigable in good weather by small boats. *Author's photo*.

its assorted swamps and feeder creeks. The proliferation of tidal marshes and estuaries in this area gave rise to fishing, oystering and boat building as principal businesses. The population was significantly smaller than that of the northern counties, and the soil was less conducive to large-scale production (with its commensurate use of slave labor).

Opportunities to slip in and out of the area were (and remain) numerous. Travel and movement among and between the various coastal towns and work sites were constant. This offered significant opportunity for individuals and families to migrate, assimilate and integrate. S.R. Ward notes:

> *At the time of my parents' escape it was not always necessary to go to Canada; they therefore did as the few who then escaped mostly did, aim for a Free State, and settle among Quakers. This honored sect, unlike any other in the world, in this respect, was regarded as the slave's friend. This peculiarity of their religion they not only held, but so practiced that it impressed itself on the ready mind of the poor victim of American tyranny. To reach a Free State, and to live among Quakers, were among the highest ideas of these fugitives; accordingly, obtaining the best directions they could, they set out for the State of New Jersey, where they had learned slavery did not exist, Quakers lived in numbers, who would afford the escaped any and every protection consistent with their peculiar tenets, and where a number of blacks lived, who in cases of emergency could and would make common cause with and for each other.* [107]

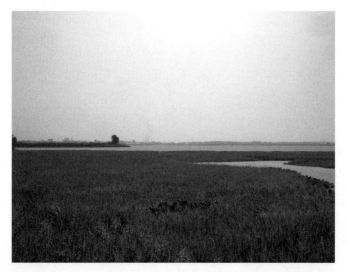

Salem River marshland is pervasive in this area. Far in the distance, barely visible just left of center, is the Salem Nuclear Power Facility, sharing the river's resources with plants and wildlife. Coexistence remains a byword in this area of the state. *Author's photo.*

Marshalltown and Salem

The bay is easily transited in decent weather by small boat at several points, and the abundance of large and small vessels plying the waterways made it unlikely that any one ship or boat would stand out. Watermen, oystermen, clammers and other boatmen knew every inch of this coastline on both sides of the bay. Even at the wider points, as between Cape May (New Jersey) and Lewes (Delaware), the bay offers innumerable creeks and inlets.

Oystering still takes place, but the beds have been disturbed and the industry no longer carries the potential it once did. Most shellfish now come from Maryland, Virginia or are expressed in daily on 747s from as far away as Australia. Fish remain plentiful, but commercial fishermen are in limited supply. The large increase in population in the region resulted in less space for natural and commercial activity and more placed into the recreational category. Fishing with small boats is almost gone. Except for the "party" boats loaded daily with city folk heading out for a guided expedition in search of flounder or bluefish, fishing remains an individual activity, for the most part.

Covering the mile or more across the Delaware at this point was adventurous in an open boat, but not unusual or unthinkable for a practiced boatman. Once across, the boat could easily traverse the reeds and inlets of the Salem River for several miles. Transporting escaped slaves through the isolated roadways of this area was less precarious than taking those routes on the Pennsylvania side (which were more heavily traveled). People escaping from Maryland and Delaware did not have to remain this close to the border, and many moved on North.

Crossing the Delaware in a skiff. This illustration is from William Still's *History of the Underground Railroad*. Such craft, under the control of competent baymen, could easily have crossed from Delaware into Southern New Jersey.

A false-bottom wagon. An 1800s "stealth" vehicle used to transport escaped slaves from one station to another on the Underground Railroad. In many cases, these wagons were already in existence and being used as a means to smuggle taxable goods from one state to another, or in operations bringing in foreign goods from ships along the coastline to avoid import taxes. *In F.G. Bordewich, Bound for Canaan, 2005.*

The need for community was a strong influence. The proximity to Salem, with its supportive Quaker influences, its opportunity for making a living and its favorable legal system, was important. Perhaps most important was the favorable legal system. Free blacks and colored people lived here, with their requirements for work and home not based on escaping from slavery. They were born and raised in the area, and they remained here. It did not always mean they were safer here than anywhere else.

Late one night, the residents of Salem awoke to the sounds of screaming and crying enough to wake the dead. Upon investigating, they saw a slave catcher, with a group of about eight blacks, naked and chained, in a wagon, heading for the river ferry. These souls were crying and wailing their fate, expecting no less than to spend their remaining days on some remote plantation in the Deep South.

A party of citizens intercepted the group and remanded the blacks to the county jail, pending determination of their status. This was standard practice for abolitionists in the days when you were considered a slave first and free only if you could prove it in court. At least while in jail the individual was safe from the slave trader and a defense could be mustered.

At trial, the slave catcher argued that these were escaped slaves. The judge failed to recognize the man's documentation and determined that there was no proof that these people had previously been slaves or that they were not free. The slave catcher threatened the court with a pistol and was summarily thrown in jail; the blacks were set free. This would have never occurred in a community without predisposed sympathy for abolition.

Marshalltown remains only in the AUMP church and a few small homes. It is probably fated to be inundated in the rising tidal flow, eliminated forever from the list of visitable small black communities in New Jersey.

Chapter 8

Dutchtown, Cootstown or Small Gloucester— Woolwich Township

Now I've been free, I know what a dreadful condition slavery is. I have seen hundreds of escaped slaves, but I never saw one who was willing to go back and be a slave.[108]
—*Harriet Tubman*

The name "Small Gloucester" crops up in several narratives of escaping slaves as one of the way stations on the Jersey route. This became confusing in doing research since there is no section of the state where this name is listed. Finally, a source mentions both names (Small Gloucester and Dutchtown), and the Dutchtown name is connected with local stories. Voila. Such is the case with these small enclaves.

Two miles seems to be about the allowable proximity of many of the small communities we are discussing to larger, more recognized towns. Dutchtown is about two miles from Swedesboro on a branch of the Raccoon Creek. That it is referred to as "Dutch" town might infer that the settlers in the area were remnants of the Dutch who came here in 1636 or so. It might also refer to the use of *Nexer Dauts* (Negro Dutch) as a language by descendants of slaves of the original settlers in this area. After the English Quakers took control and manumission became fashionable, about 1793–95, an existing common language continued.[109]

There is evidence that blacks and colored slaves in northern New Jersey and New York picked up the language of the Dutch and retained use of this as a slang over several generations. Several indications of cultural assimilation are noted among the slaves and former slaves of Dutch farmers on Long Island, including the adoption of *Paas* (Easter) as a high holiday.

James Storms, the last known speaker of Jersey Dutch, noted:

A Swedish/Dutch cabin—Swedesboro. This structure is typical of the size and construction of log cabins of the early period. The design remained standard fare for dirt farmers, itinerant laborers and pioneers moving westward as late as the mid-nineteenth century. It was easy to construct in a short time, providing the essentials until the land could be cleared and crops laid out, and it was certainly better than a canvas tent. *Author's photo.*

Even the colored people, for the most part children of slaves, without any education at all, were proficient in the use of Jersey Dutch and had enough knowledge of English to converse in either.[110]

It is not impossible to surmise they did the same in South Jersey.

The Swedes and Dutch who came into this area of Raccoon Creek were prepared to settle in for the long term. They cleared land of virgin forest and plowed the earth to initiate subsistence farming alongside the cash business of pelts and timber. They lived in nothing even remotely as comfortable as the native longhouses. During the winter and inclement weather, the family sheep, goats and cattle lived in the shelter along with the family. Life was a bit crowded, and conditions and sanitation were a bit complicated; spring cleaning had a meaning much different from today. There are references to Indians complaining about the odor from the white homes, which is understandable considering the poor hygiene of the colonists at that time and their cohabitation with livestock.

The typical homes of these first arrivals tended to be simple and plain. As noted, domesticated animals may have occupied the same room as the family in inclement weather. In better homes, farm animals may have been

relegated to a part of the "root" cellar, along with properly secured food supplies (potatoes, apples, gourds and squash). The first homes in Dutchtown were certainly not the fine surviving examples of Colonial and Federal architecture we see today. Larger homes awaited the arrival of population, greater need and greater wealth.

A typical layout consisted of one or two rooms with a loft and a roughed-out cellar. In summer months, the family often lived in the "summer kitchen," usually a fireplace for cooking located in the below-ground level of the home or in a section dug into a hillside. Meals were prepared here when cooking could not be done outside, and preserving and canning took place there to "put food by." This practice of constructing a summer kitchen continued for quite some years due to the warm, sticky weather of the mid-Atlantic. Such elements remain a part of the basements in some of the old homes now standing.

According to Peter Kalm, in his book *The America of 1750*:

> *The houses of the first Swedish settlers were very indifferent; it consisted of but one room; the door was so low as to require you to stoop. Instead of window panes of glass they had little holes, before which a sliding board was put, or on other occasions they had isinglass; the cracks between logs were filled with clay; the chimneys, in a corner, were generally of gray sandstone, or for want of it, sometimes of mere clay; the ovens were in the same room. They had at first separate stables for the cattle, but after the English came and set the example, they left their cattle to suffer in the open winter air. The Swedes wore vests and breeches of skins; hats were not used, but little caps with flaps before them. They made their own leather and shoes, with soles (like moccasins) of the same material as the tops. The women, too, wore jackets and petticoats of skins; their beds, excepting for the sheets, were of skins of bears, wolves, &c. Hemp they had none, but they used flax for ropes and fishing tackle. This rude state of living was, however, in the country places principally, and before the English came, who, rough as they must have also lived for a time, taught a comparative state of luxury.*

This southern portion of New Jersey was (and still is) heavily influenced by Philadelphia and the settlements initiated by William Penn. Quaker and free black philosophies tended to prevail in the discourse of the nineteenth century. These factors gave runaways early opportunity to enter the area, obtain assistance and remain essentially unnoticed.[111] To be sure, slave catchers (those who were good at their work, at least) were aware of this, as

well, and they traveled the region extensively in search of anyone who might be a runaway (or a good prospect for kidnapping and selling South). But the vast areas of flatland, crisscrossed with streams, marshes and creeks, like the crazing marks on an old vase, made traveling and searching a nightmare.

Today it would be less likely for someone to remain unnoticed in New Jersey because the rural nature is transcended by modern surveillance technology. Though the southern portion remains somewhat isolated and remote in spots, the state as a whole has surpassed the population density of India as of the 2000 census. What are referred to as "mushroom farms" sprout almost daily on former farmland and any available dry spot. The expanse of McMansions has hit the region as commuters move farther and farther into the country from their jobs in Philadelphia; Wilmington, Delaware; or Atlantic City casinos. Yet, in the region being discussed, large swaths of remote farmland remain, giving an image of the times before.

One sees the fields and mill dams of an agricultural community in this area, even today. Hendrickson's Mill is located around the corner from

Hendrickson's Mill Pond from Hendrickson's Mill Road, about one-half mile from the Mount Zion Church. It is well within the area indicated on tax maps as being heavily populated with black and mulatto families. The mill on this property was fed power by the dam over which the road now runs. It was, most likely, one source of employment for escaped slaves and free blacks. *Author's photo.*

the Small Gloucester Mount Zion Church. Such businesses and farms would have provided seasonal and day work for the residents, much as did Sheppard's Mill, Evans' Mill and others. Domestic work would have been available in Swedesboro, a mere hour's walk away. Fowl and game abounded in the woods and streams, and individual farmsteads would supply cash crops and vegetables for family use.

Life in this agricultural setting was seasonal. The social limitations placed on blacks and colored folks, even in the "free" North, essentially left them no choice but to work as laborers and servants. Seasonal work required little in the way of skills, other than those learned as youngsters on other farms. Often, former slaves would recount their "birthdates" as the season in which they were born—peach-picking time, hog-killing time, wheat-planting time, etc.[112]

Education might be minimal, but a person could still earn a living. Processing food was a full-time effort. One of the seasonal events noted in many of the diaries is "Hog Killing" time. John Watson's description of that process is about as clear as it can get:

After the first good cold spell of the year was the time to butcher the hogs so that the meat would keep better in the smoke house in the cold weather. All the neighbors were invited over to help with the preparation and each one would be given some meat to carry home with them.

On the morning of the big day, the neighbors would start arriving about daylight, some of them bringing extra 30 or 40 gallon wash pots. Yes, these were the same pots that were used to wash clothes in but were used today to heat water to scald the hogs. By scalding the hog in the barrel of hot water, that would loosen the hair and make it easier to scrape off. The bacon and hams were prepared with the skin left on, (the rind as it was called), and they didn't want any hair left on when they went to cook it. As soon as they finished scraping, then the hog was dressed out and quartered up.

Some of the meat would be set aside to make sausage with. This meat would be ground with a small hand cranked sausage mill and then peppers and spices would be added to make the sausage. This was usually done after everyone had gone home. Being young, this was about the only thing I got to help with.

After the last hog was scalded, then all the excess fat that had been trimmed from the meat was put in one of the pots to cook the lard out. The lard was stored in five gallon buckets for use during the coming year. In the process of cooking the lard out we got some great cracklings. You buy them at the store today in packages labeled pig skins. There was nothing better

Mount Zion AME Church is located on Garwin Road just a few hundred yards from Route 322 in what was called Small Gloucester or Dutchtown in references to the Underground Railroad routes in New Jersey. Small Gloucester is noted as one of the stopping places of Harriet Tubman when she made use of this route. *Author's photo.*

than getting a fresh hot crackling right out of the pot to eat. Of course mother would make some crackling bread later.

A few days later, mother would take some of the lard and put it back in the wash pot and heat it up and mix some lye with it to make some lye soap. This was used to wash your hands with, for bathing and to wash your clothes with. Mother usually tried to make enough to last a year, until next hog killing time.[113]

The Mount Zion African Methodist Episcopal (AME) Church, a small one-story frame meetinghouse built in 1834, was one of the important Underground Railroad stations in Small Gloucester from the time of its construction until the beginning of the Civil War. Small Gloucester (Dutchtown), emerged in the early nineteenth century as one of these African American settlements.

Members of the Mount Zion AME Church supported the Underground Railroad and actively provided protection, supplies and shelter for runaway slaves. The church community was always a safe haven, and several original

members of the congregation, including Pompey Lewis and Jubilee Sharper, directed conductors, engineers and slaves north after taking care of their personal needs.[114]

Many of the congregations in these small communities started as associations for the purpose of burying folks. While it was common practice among larger landowners to have family plots located on the family farm, there was a need for a communal burial ground for those without assets or estates. Dutchtown has its own small, AME cemetery. Surrounding it are several large, suburban homes belonging to the commuters now living here.

The 1850 census of Woolwich Township includes descriptors of the colored families living in this area. The individual and his occupation (women did not "work," remember), as well as the family and their race, are listed. Note that some of the individuals and families are indicated to be "from" other states. It is likely that, at this time, these folks had papers indicating they were "free" or they would not have told the census taker they were "from" Maryland or Delaware. Both were still slave states, and escaped slaves would have been pinpointed by telling of their origin.

Woolwich Township—in 1850 Census

Francis Spry (79) (mulatto) and Lydia (80) (black) and Mary Farmer (18) (black)

Charles Jase (16) (mulatto) from PA; Allen Jones (30) (mulatto) and William Stewart (15) (black) both from PA

William Corsy (31) and Lydy Ann (21), Benjamin (4), William (2) and Mary Ann (9m) (black)

Priscilla Farmer (50) (mulatto) and Ellen (13), Henrietta (10) and Francis (5) (black)

Hannah James (18) (black); Margaret Thomson (14) (black); James Wilson (11) (black)

Mary Ann Groos (25) (black); Catherine Murray (15) (black)

Robert Smith (40) (black) from DE, laborer, Hannah (22) and Jeremiah (5) (black) from PA

Peter Griffee (18) (black) laborer; Henry Wilson (26) (black) laborer; Robert Wells (38) (black) laborer

John Brown (29) laborer, and Elizabeth (17), both from MD William (2) and Emily J. (4m) (mulatto) and Maria Engle (8) (mulatto)

James Taylor (36) from MD and Julia Ann (27), Harriet (12), Franklin (9), David (7), Esther (5), Susan (3) and John Henry (1) (black)

Henry Baker (37) farmer, and Rebecca (30), Esther E. (10), Delia (8) and John (2) (black)

George Butler (30) laborer, and Mary Ann (23), Anna Maria (6), Peter (3), Rachel (4m) and Anna Carnall (6) (black)

George Smith (29) laborer, and Matilda (25), Ann E. (6), Amelia (4), Jesse (5m) (black) in same home: John Lewis (20) laborer, and Margaret (25) and Henry (2m) (black)

William Accou (30) laborer, and Susan (29), Sarah E. (10), Esther (8), Rebecca (6) and Sinnickson (3) (black)

William White (33) (mulatto) laborer, and Mary (35) (black) and Thomas (13), Moses (11), William (9), Hannah (6), Robert (4), Elizabeth (2) and Nathan (5m) (mulatto)

William Howard (21) laborer and Hannah (16) (black)

Rachel Campbell (45) and Anna (6) and David (10) (black)

Of note is that, according to historian Giles Wright, the surname "Accou" is distinctly African. This indicates that William (noted above) retained or readopted his original family name. It begs the question: "Why?" Was there oral history passed down of family and relatives from Africa? Was he involved in discussions about the Liberian experiment and movement to Africa? Such is the level of research needed to flesh out the lives and histories of these people.

Chapter 9
Saddlertown and Haddon Township

There is a marker near a plot of woodland in the midst of busy, crowded Haddon Township, Camden County, New Jersey. Most people, perhaps even all people, in this commuter suburb of Philadelphia likely don't know and don't care about the marker. It notes the unplanned achievement of a man who became progenitor of a small piece of free soil. It notes that he was the first "non-indigenous" person to initiate preservation of natural resources in the county. The woods situated in the middle of a schoolyard and modern homes were the property of one Joshua Saddler.

It is known that in the early 1800s, a fugitive slave, Joshua Saddler, escaped from a Maryland plantation. He reached New Jersey and soon found work with Josiah or "Cy" Evans, a local Quaker farmer. Upon learning of his new employer's negative feelings on slavery, Joshua Saddler told him of his escape. Records show that Josiah "Cy" Evans arranged to purchase the freedom of two fugitive slaves, Joshua Saddler and Jonathon Fisher, rather than have them picked up by a bounty hunter. Mr. Evans received word of inquiries being made about Saddler by his old master, who was in New Jersey on business. Mr. Evans feared for Saddler's safety and eventually was able to bargain with the plantation owner to sell him the runaway slave for a rather small sum. This act secured Saddler's safety and freedom.

Records also show that Jonathan Fisher was Joshua Saddler's son-in-law and not an alias for Saddler himself, clearly pointing to a family, or at least a daughter, accompanying Saddler. Saddler and Fisher remained at the family mill, working to repay Evans for his kindness.[115] Joshua Saddler was apparently a very frugal and hardworking individual to be able to use his labor alone to build a home and property. This aspect of the emancipated slave and free person of color is noted over and over in the various descriptions of individuals and families. It appears to be purposely repeated and emphasized because of the common stereotype of the free black as reluctant to work and difficult to direct.

Saddler's Woods today is a reconditioned nature preserve and walk isolated from the continuous hustle of this conjunction of major and minor highways leading to Philadelphia. It is a pleasant diversion, just as Joshua Saddler would have liked. *Author's photo.*

Those stereotypes, according to T.G. Steward, Ernest Lyght, Edward Heite, James Still and many others, seem to be derivations from the work ethic of slaves. In fact, one consistent argument made against the claims of Southerners that slavery was essential to the economics of the area was that blacks worked far better and more effectively as free tenants than they ever did as slaves. This issue is raised over and over wherever people are held in bondage or servitude, rather than being provided with the opportunity for self-direction and personal benefit from their labors.

Saddler did well in the area, eventually purchasing plots of land and building a small house. As word spread of the new haven, other African Americans came and built homes. In time, just as with the initial founding of the colony of West Jersey by Fenwick and others, a community formed and was named "Saddlertown" in honor of Joshua Saddler.[116]

Saddler went on to become the leader of this small settlement of freemen and former slaves in what is now Haddon Township. Situated within the larger environs of Camden County, it is only about four miles from Philadelphia. With the center of activity in the Underground Railroad being in that city, it was often necessary to locate refugees in the surrounding environs of Pennsylvania and New Jersey.[117] The references made in narratives to

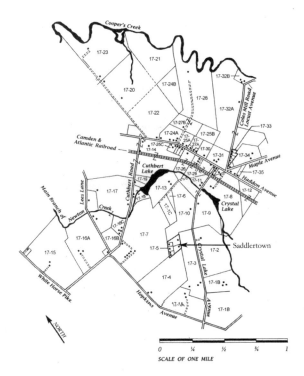

The situation of Rhoads Chapel and Saddlertown within Haddon Township, tax ratable map. *Camden County Library.*

"Camden" lead one to believe that Saddlertown could easily have been on the list of safe havens, in addition to the larger, better-known Snow Hill. Snow Hill, in fact, is about two miles from Saddlertown and could easily have been a sustaining influence for the smaller community there.

Nevertheless, the threat of abduction and return to slavery was ever present. The proximity to a Quaker settlement did not preclude this fate. The only sure safety was a fierce resistance or migration to Canada. S.R. Ward recalls:

> *My father had a cousin, in New Jersey, who had escaped from slavery. In the spring of 1826 he was cutting down a tree, which accidentally fell upon him, breaking both thighs. While suffering from this accident his master came and took him back into Maryland. Two of my father's nephews, who had escaped to New York, were taken back in the most summary manner, in 1828. I never saw a family thrown into such deep distress by the death of any two of its members, as were our family by the re-enslavement of these two young men.*[118]

Antebellum Camden, only three miles down the road, was not the industrial city it would become, with RCA, Campbell's Soup and a hundred

Rhoades Avenue, Saddlertown. A visit will show you the chapel and a few homes that could have been period to Joshua Saddler's descendants. Most residents know little of the history of this section of Haddon Township. *Author's photo.*

other manufacturing and industrial companies plying the wharves of the Delaware River across from Philadelphia. It was a landing on the Jersey side of the Delaware, surrounded by Quaker farms and rural communities. The principal large agricultural entity in the area was the plantation. Elizabeth Haddon's Fields was one of the larger of the plantations established in the area by the English upon their arrival.

Though we often think of plantations as indigenous to the Southern United States, in fact plantations existed in West Jersey. They evolved over time, from the relatively tight, plain complexes of the Swedes and Dutch to replications of English country homes and estates, as early as 1700.

Plantations generally incorporated production of all necessary goods on-site and maintained a good number of fowl and livestock in addition to growing traditional crops such as maize (corn), barley and wheat. Additional crops would have been flax and hemp; the one for making oils and linen, the other for roping. Beer would have been produced as a way to ensure the consumption of minerals and vitamins more than as a social drink. Beer was consumed by all members of the family as part of each day's meals and was considered essential to the survival of the settlers.

Family was the center of support and activity. This condition reigned through to the early twentieth century. There would be no real difference in the perception of the value of family and kinship among the diverse populations being looked at. What would differ would be the opportunity to build, maintain and sustain an intact family. Emphasis on the trades and agriculture meant seasonality. Work varied according to the seasons. A spouse was, as much as a companion, a requirement for survival. Mary Patterson Moore notes:

Evans Mills, as shown in an old photograph, circa 1910. This is most likely the mill complex where Joshua Saddler worked off his debt to Cy Evans and earned enough to build his own farm. *Paul W. Schopp Collection.*

In those days every young man was looking for a wife; he could not make his way alone in the world. His wife was to help him make a living. If he had a farm he was considered to be well-to-do, and there was no difficulty. If he could rent a farm and a pair of horses plus, perhaps, a cow, that was a good beginning. If he had a trade he could rent a house, get a little furniture; he and a wife would soon be able to get more. In the meantime, there was love to help the first year and that helped much.[119]

Croft Farm, now a restored historical farm, replicates this. Part of the original Evans complex of farms, mills and family homes, it may have played a role in secreting and transporting refugee slaves. The members of Haddonfield Meeting played a role, but a larger role was played by the small enclave of free blacks in Saddlertown and nearby Snow Hill. Saddlertown served as an optional way station for those moving along one or another of the New Jersey Underground Railroad routes; a convenient alternative for hiding, perhaps even settlement and work, within the confines of Haddon Township.

Now a very well-to-do community (with property taxes to match), Haddonfield is separate from the township of the same name. On Rhoades Avenue, off of McArthur Boulevard in Haddon Township, sits the Rhoades Chapel AME Church of Saddlertown.

Rhoads Avenue M. Church, Saddlertown Section, Haddon Township. Historic Rhoades Chapel was built by Quakers as a school for African American children and is now a church. *Author's photo.*

Saddler's Woods is a twenty-five-acre urban forest located in Haddon Township, New Jersey. Saddler's Woods surrounds the headwater spring of the main branch of the Newton Creek, a tributary of the Delaware River in Camden County, and is unique for its combined features of an old growth forest, young woodlands and wetlands, all located within five miles of Philadelphia.[120] According to the Saddler's Woods Conservation Association,

> *In 1868, Joshua Saddler wrote into his will that none of his heirs "shall cut the timber thereon." For this early preservation ethic, the woods, formerly known as the MacArthur Tract, were officially named in his honor in January 2004.*

Saddlertown became engulfed by expanding Haddon Township. Homes were built, and farms were divided among surviving family members. Now, situated in the middle of suburbia, Saddlertown holds onto only a portion of its original flavor. The project to preserve Saddler's Woods ensures that this haven will not disappear completely.

Chapter 10
Snow Hill (Lawnside)

I was born February 11th, 1783, at Cape May, State of New Jersey. At the age of seven years I was parted from my parents, and went to live as a servant maid, with a Mr. Sharp, at the distance of about sixty miles from the place of my birth.

—*Jarena Lee, 1836*

Though not uncommon, such outplacement of children as servants was still a worrisome and trying experience for a young person and her family. What is not often obvious in the readings are the periods of depression and anxiety these arrangements brought about in both parents and children.

Jarena Lee's story, while primarily a litany of her religious conversion and preaching, provides insight into the life of someone left on her own at an early age and the role of the black communities in raising orphaned or lost children. Lee alludes to this in her poetic allegory about attempting suicide. She relates how she was overcome with guilt after hearing a preacher discuss one particular passage from scripture and was told (by voices, perhaps) to end her existence:

> *Not knowing how to run immediately to the Lord for help, I was driven of Satan, in the course of a few days, and tempted to destroy myself. There was a brook about a quarter of a mile from the house, in which there was a deep hole, where the water whirled about among the rocks; to this place it was suggested, I must go and drown myself.*
>
> *At the time I had a book in my hand; it was on a Sabbath morning, about ten o'clock; to this place I resorted, where on coming to the water I sat down on the bank, and on my looking into it, it was suggested that drowning would be an easy death. It seemed as if some one was speaking to me, saying put your head under, it will not distress you. But by some means,*

of which I can give no account, my thoughts were taken entirely from this purpose, when I went from the place to the house again. It was the unseen arm of God which saved me from self-murder.

Lee continued to attend services and to challenge her own beliefs. She received support from her employing families, as well as from the colored community. During the next few years, she recounts several recurrences of her "temptation by Satan" to destroy herself. At one point, she states:

For if all I had passed through was to go for nothing, and was but a fiction, the mere ravings of a disordered mind, that I would naturally be led to believe that there is nothing in religion at all.[121]

This is quite in line with the manifestation of schizophrenia, depression or some other similar mental illness. Today, we have medication to manage these illnesses; at that time, Lee turned to preaching to resolve hers. In the course of pursuing this calling, she became the first approved woman preacher in the recently formed African Methodist Episcopal Church.

Though a traveling preacher throughout her career, Lee is inescapably connected to Snow Hill (now Lawnside), New Jersey. If one draws a compass

Jarena Lee, preacher of the AME Church. Aged sixty years on February 11, 1844, Philadelphia. *New York Public Library Collection.*

circle sixty miles from West Cape May, it intersects roughly with the locations of Snow Hill (Lawnside) and Haddonfield. While this is speculation, it would make sense that Lee was familiar with the area of her future husband's family prior to moving there a few years later to be married. There was regular communication between and among the various small black enclaves and the larger black and colored populations of Philadelphia. In addition, it is noted in the histories that Joseph Lee was an itinerant pastor serving this congregation in 1811, when Jarena Lee moved there from Philadelphia. After initial discomfort at moving from her friends in Philadelphia, Jarena Lee settled in to assist in the "care of the sheep" at this place and to raise a family.

The Community

Haddonfield has a long history in Southern New Jersey as a Quaker Meeting and as a very wealthy center of professionals and merchants. As noted previously, in terms of expensive housing and land in present-day New Jersey, Haddonfield ranks up at the top of the list for pretentious and expansive lifestyle. Just outside of present-day Haddonfield lies the incorporated town of Lawnside. Lawnside, in stark contrast to its neighbors, has maintained its long tradition of practical lifestyle. As with all of West Jersey, it traces its legal status to the purchase of land from the West Jersey Proprietors. Charles S. Smiley notes:

> Lawnside is situated on the tract of land known as the Dublin Colony, the Third (or Irish) tenth, West Jersey. It was purchased of Edward Byllynge of London, England, in 1677 by Francis Collins. It was surveyed in 1682.

Lawnside holds the distinction, at least in New Jersey, of being the only incorporated municipality expressly chartered during the "separate but equal" days as a black community. It also ranks among the most modest of New Jersey communities. Perhaps this is in keeping with its tradition as a stop on the Underground Railroad. Keeping a low profile was not only a common practice, but it was also essential to avoiding recriminatory attacks by outraged whites and slaveholders. Keeping a low profile and caring for their own has been a tradition here for so long that it has become instinctive in the residents.

Lawnside was an area originally founded in the 1700s by colored farmers and woodcutters and eventually named Free Haven. This was a haven for free blacks and escaped slaves, particularly following the general

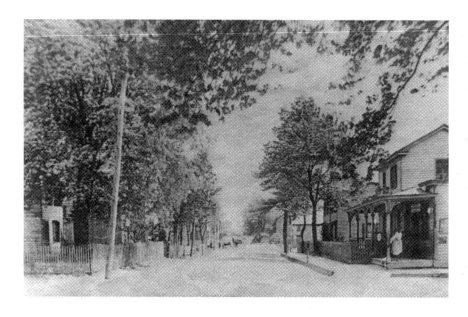

Above: Warwick Road, Free Haven, circa 1880–90, was a more relaxed and less-traveled route, with remnants of farms and orchards along its path. Homes along this road were stately manors of merchants and well-off professionals among the black community. *New York Public Library Collection*.

Left: Warwick Road, 2008, is a routine thoroughfare between Berlin and Haddonfield and an alternate to the busier and more congested Route 30 (just a few blocks south). An entrance ramp from the road to Interstate 295 lies just opposite the Mount Pisgah Church. The community, like much of New Jersey, is no longer rural. *Author's photo*.

emancipation of slaves by the large population of Quakers in South Jersey about 1797 to 1800.

The town was also called Snow Hill by others in the surrounding communities; because it sits a little above the flat plain of the area, from Haddonfield and other nearby towns it could be seen to have a white "sugar" sand tone to it (the white sand found in the Pine Barrens).[122] Another story is that it was named by escaping slaves who came from Snow Hill, Maryland, but reference to the place as "Snow Hill" by Jarena Lee as of 1811 seems to make this improbable. In any event, it is shown on the 1834 map of New Jersey as a bona fide "town" (it has a dot, not just a name). The work there was agricultural, in stark contrast to today's Lawnside.

Lawnside was a black community for over a century before separating from Centre Township in 1926. It was a formal community at least as early as 1811, when Jarena Lee moved there to marry her husband, Joseph Lee, noting the place in her diary as "Snow Hill." It was known as Free Haven (or Snow Hill) until the railroad passed through and named the station there Lawnton; thus, the name of the town became Lawnside. It was a fringe enclave, where landowners pursued their own endeavors. Smiley writes:

If you had never been there before you would have trouble finding the place—log cabins with small clearings cunningly concealed from the road (Old Egg Harbor Road).[123]

In the manner of almost all of the communities being looked at, Free Haven was a fringe settlement. The colored community was located sufficiently outside the bounds of the principal white community to avoid conflict, but close enough to provide labor to that community (and stimulate cash jobs for residents). The factor that brought the local population to a focal point, as with almost all towns, was a mill and/or church.

The formal Methodist Episcopal congregation at Snow Hill was formed as early as 1803 between colored and white members. Charles Smiley, in his history of the town, notes Methodist classes and education for people of the area as early as 1797. Histories available often cite earlier dates for the establishment of a congregation here, particularly that by an emancipated slave named John Hinchman (Hichman). However, there is no substantiation that a formal congregation was started by Hinchman or that formal religious efforts at establishing a school and center of worship occurred prior to about 1797. A John Hillman is noted to have owned and run a tavern on his estate in the vicinity as early as 1697.[124] Perhaps it is this Hillman who encouraged early gathering for worship at his tavern, or near there.

Peter Mott House, Lawnside. On the list of National Historic Preservation Sites, this home was nearly demolished to make way for condominiums. Parishioners of local churches and the Camden County Historical Society fought to achieve historical status for the home. Mott was of one of the founders of the AME church in Snow Hill and one of the Underground Railroad's most prolific station masters in the vicinity. *Author's photo.*

The congregation in Free Haven/Snow Hill followed suit with those of many others in offering safe haven for escaping slaves. One of those heavily invested in the process of assisting self-emancipators was Peter Mott. An elder of the church and a local businessman, Peter used his home and those of his neighbors as places for refuge and asylum.

Mott was an early leader and preacher in the community, lending his influence and efforts to the incorporation of a Methodist Episcopal Church in the area of Free Haven in 1808.[125] The church was served by itinerant ministers such as Joseph Lee (from Cape May Circuit) and Richard Allen (from Philadelphia Circuit) prior to the breakaway that formed the African Methodist Episcopal Church in 1811.

The community that would become Snow Hill was likely in place by the 1700s, and was linked closely with Haddonfield. The 'fringe' lands, with poor soil and swampy terrain, were usually left by the wealthier landowners for anyone willing to take a chance at farming them. This was no different in Snow Hill.[126]

That whites and blacks congregated for worship under either the Presbyterian, Methodist or Baptist ideologies is likely. However, it would appear that Peter Mott and Ebenezer Mann initiated the first regular Snow Hill worship in a small home or building donated by the Methodist Episcopal Church of Haddonfield.

A first official meetinghouse was built on the site of the present-day Mount Pisgah AME Church, though facing Mouldy Road instead of Warwick Road.[127] In 1815, the whites withdrew, leaving the black members in charge.

Snow Hill (Lawnside)

As noted, in 1926 Lawnside (Free Haven, Snow Hill was incorporated as its own municipality through petition to the New Jersey legislature. By that time, there had been economic and social growth in this all-black community to the extent that it had formed its own municipal government, support services (fire and police) and infrastructure. In Paul Cranston's *Camden County: The Story of an Industrial Empire* (1931), the author tells much about intercommunity relations by what he does not say. He notes Lawnside as a "model" community. He announces, "Here is a community free from pretence, but full of pride." This sentiment has been repeated during interviews with current residents.

Cranston continues, "The people are self-respecting, law-abiding citizens, entirely self-governed." Similar descriptions are not found in discussion of the principal white communities of the county; they are simply assumed to be true. Without going into detail about the culture and social conditions in colored communities, as assumed by the white majority and media, it is sufficient to say that such unwritten boundaries between the colored fringe communities and wealthier white communities remain intact, even to this day. Reverend Jim Benson states it more eloquently:

> *Lawnside is a close-knit community. If you grow tomatoes and I grow squash, I am never lacking for tomatoes and you are never lacking for squash.*

Snow Hill's early school system was much like other small communities in New Jersey. Charles Smiley notes that a single-room school was provided in 1848 by the benevolence of a Haddonfield man. Prior to that, school was taught in the home of the teacher, in the church or in another structure of sufficient size and location to suit the need.[128] Often this was a fair distance from home. As Smiley notes:

> *Children came from miles around, walking there and back. Many a real battle these children had, for they were not as intelligent as we are today; neither were their enemies. Therefore, they must be courageous; a cowardly child could not overcome the difficulties.*

It would appear that walking two miles to school, uphill both ways, barefoot on hard stones, was as common in Snow Hill as in my grandfather's Sicilian village. The "battles" referred to, however, most likely refer to actual or attempted kidnappings by slave sellers and racially fueled attacks by local residents lining the road to school. Such were common practices in 1848 60,

as the Fugitive Slave Law took hold of the country, and concern about the effect of free blacks moving into the labor market spawned fear of job loss among newer immigrant populations, such as the Irish.

Until the latter part of the twentieth century, farmers in Snow HIll took produce to Philadelphia for sale. This practice was common among the rural population, gaining needed cash from the sale of vegetables, corn and processed meat to the city folk. Snow Hill residents applied this cash-and-carry principle just as did their white neighbors, using the income to develop small business and home-grown enterprise in their town.

By the turn of this century, Snow Hill (now Lawnside) had evolved to being simply another section within the larger township of Union in Camden County. The 1926 incorporation has kept its identity distinct, even while communities around it expanded, their borders blending into what is now a compacted metropolitan suburb of Philadelphia.

Friendship Lodge, No. 5, Free and Accepted Masons (Prince Hall Lodges), was chartered in Snow Hill in 1848 before moving to Camden's Kaighnsville section as the Union Grand Lodge in 1850. It was one of the earliest black fraternal organizations in New Jersey. The FAM returned to Lawnside with the formation of the Hiram Lodge in 1875 by the Union Grand Lodge. At the time, it represented a formalization of the philosophy

Mount Pisgah AME Church today. The church retains its standing in the community as a center of education and assistance for the population. *Author's photo.*

of community support and cohesion that had been in place since the founding of the place.[129]

Formation of fraternal and other support organizations and associations was an important element in the transformation of these fringe communities into social, economic and political entities in their own right. The associations formalized, and secularized, the role previously played only by the various churches. As such, a parallel would be the gradual transformation of economic wealth from the Catholic Church to secular guilds and economic partnerships in medieval Europe.

Associations outside of the church became important between and among citizens of the several communities of color, much as the "meetings" had been important to the early Quakers in establishing a network of business and social links.[130] As the black abolitionist movement expanded and demanded a greater role in government and economics, the black lodges and associations played a role in uniting the small, far-flung communities into a cohesive political body. But this was only in its early stages until after the Civil War.

INFLUENCING OTHERS

Joseph Lee died in 1817 and Jarena, with only two of her six children still living, fell into another depression. In attempting to manage this most recent "attack by Satan," she once again resurrected her faith as a calling. Relying on friends she now had in the community of Snow Hill, she left her children with them and proceeded to resume her exhorting and preaching. She traveled the itinerant route of the preacher of the day. At one point, accompanied by Sister Mary Owen (another exhorter) and an unnamed male elder, she traveled to Salem, New Jersey, to take over a role in that congregation. Her comments are telling of her determination and drive in a male-dominated society and church hierarchy.[131]

> *I stayed a short time* [in Philadelphia], *and went to Salem, West Jersey. I met with many troubles on my journey, especially from the elder, who like many others, was averse to a woman's preaching. And here let me tell that elder, if he has not gone to heaven, that I have heard that as far back as Adam Clarke's time, his objections to female preaching were met by the answer—"If an ass reproved Balaam, and a barn-door fowl reproved Peter, why should not a woman reprove sin?" I do not introduce this for its complimentary classification of women, with donkeys and fowls, but*

to give the reply of a poor woman, who had once been a slave. To the first companion she said—"May be that a speaking woman is like an ass—but I can tell you one thing, the ass seen the angel when Balaam didn't." Not withstanding the position, we had a prosperous time at Salem.

Lee went into Delaware and Maryland, still slave states, risking arrest and enslavement for preaching to slaves and teaching them about "freedom." Throughout this journey, she related speaking at and staying in homes of Quakers, Methodists and Presbyterians. Such collaboration indicates that sentiment toward the "colored" population was not consistent in that slaveholding area. Her children were cared for in the tradition of extended family provided by the members of the small, Snow Hill community. Lee was often cared for by families living in the string of small, isolated, free black settlements running along the Delaware/Maryland peninsula.

Lee's preaching (and that of others) in Cecil County, Dorchester, Camden and other places in Maryland, as well as in Wilmington and Newcastle in Delaware, raised spirits and aspirations; many of the slaves who chose self-emancipation during this period relate their initial inspiration as being one or another of the camp meeting preachers. On the Sabbath (and on some other days during a month) some slaves were permitted passes to go to meeting, visit family members on other plantations or work on their own plots and trades for personal gain. Many attended meeting. Lee notes:

I next attended and preached several times at a camp meeting, which continued five days. We had Pentecostal showers—sinners were pricked to the heart, and cried mightily to God for succor from impending judgment, and I verily believe the Lord was well pleased at our weak endeavors to serve him in the tented grove.

One of those in the audience at several such camp meetings was Harriet Tubman. Tubman related that, upon hearing sermons from the likes of Jarena Lee, Mary Owen and others, she was moved to free herself of the yoke of slavery.[132] It was this very encouragement for slaves to seek a life outside of captivity that produced ever-more-violent and recriminatory reactions from slaveholders and legislators against preachers and the black church. It appears to be this reaction by the majority that eventually brings a political cohesiveness to the AME, African Presbyterian, African Episcopal and African Baptist organizations that surmounted their philosophical differences.

Chapter 11

Evesham Meeting and Jacob's Chapel

I had grown up quite large, before I thought any thing about liberty. The fear of being sold South had more influence in inducing me to leave than any other thing. My feet were frostbitten on my way North, but I would rather have died on the way than to go back.[133]

—*William Johnson*

E vesham is within a well-to-do section of Burlington County, near present-day Moorestown and Cherry Hill. This area was settled around the same time as Burlington City (1677–80). Also located about two miles distant is the Croft Farm (noted above). Evesham remained very rural until the middle to late nineteenth century. At present, it is among the most densely populated and expensive sections of South Jersey.

On the Jersey Underground Railroad route, Evesham Meeting is regularly noted as a principal way station. The resident station manager, according to Emma Trusty, was John Coleman.[134] The Colemantown Cemetery, at the rear of Jacob's Chapel, and the use of the place name "Colemantown" for the area around Jacob's Chapel, seem to bear this out. While there is still a lot of investigation required to confirm the role of a Mr. Coleman, the role of Evesham is clearly mentioned in several sources.

The term "meeting" has often been associated with the Society of Friends. However, in the early periods of most congregations, a "meeting" was simply the place where everyone met for worship. Evesham Meeting, in that sense, might easily refer to the Colemantown cemetery and meeting house now referred to as Jacob's Chapel, rather than to Evesham (or Mount Laurel) Meeting of the Quakers.[135]

The slaves came from Woodbury and were received by Thomas Evans, then quickly hidden in the attic of the house so that no one could find them. Then, in the middle of the night, they would be given something to eat and

Jacob's Chapel in Mount Laurel. The original site (left) was built in 1813. Today, the church has a very vibrant and active congregation. *Author's photo.*

hurried off in a covered wagon to Mount Holly, where they were received and hidden again.[136]

Located about two miles from Moorestown, on Elbo Lane, off modern-day Moorestown–Mount Laurel Road, is Jacob's Chapel. Jacob's Chapel is significant in several ways: first, it was one of the earliest AME congregations established under the tutelage of Reverend Richard Allen after the break with the Methodist Episcopal Church; second, its congregation was known to have provided support and assistance to people traveling the Underground Railroad; and finally, it was the home congregation of members of the Still family, who were renowned as leaders in the black community in Central–South Jersey for decades.[137]

A noted resident of the area was William Johnson. His narrative, recorded when he was living in St. Catherine's, Ontario by Benjamin Drew, recalls escaping from a plantation in Maryland and spending several years living and working in Evesham until he was captured by slave hunters. At trial in Mount Holly to determine the legality of the slave catcher's claim, he was freed on a technicality and immediately left for the North.

Harriet Tubman sums up this driving force to get to Canada, despite having an apparently satisfying life in Evesham, New Jersey or elsewhere in the free North:

Then I was not happy or contented: every time I saw a white man I was afraid of being carried away. I had two sisters carried away in a chain-gang,—one of them left two children. We were always uneasy.[138]

The farms and settlements in the immediate vicinity mirrored those of Marshalltown, Springtown and other communities. They provided support

Evesham Meeting and Jacob's Chapel

Colemantown Cemetery, to the rear of Jacob's Chapel. The cemetery preceded construction of the church (as did many) and holds many descendants of the Stills. *Author's photo.*

for families and individuals, as well as workers for the larger, white farms and communities nearby. Because of the significant Quaker influence, these businesses hired on labor instead of buying slaves or indenturing. As a result, individuals had a source for cash income, as well as time to pursue their own farming and business activities.

To some extent, settlements of the area can be traced in the architectural styles of standing structures. Though not critical to this discussion, per se, the types of buildings in a place help to open discussion of the people living there. In that sense, there is evidence that certain structural styles emanated in the Southern plantations and among the African slaves. These styles were incorporated into the homes they constructed on the plantation, as well as within the free community.

As the wealth and relative social standing of black, Indian and mulatto families grew during the late eighteenth and nineteenth centuries, it is the adoption of more classical Federal-style or Victorian architecture for their homes that evidences their standing. That these still tended to be in isolated locations (or in enclaves) speaks to the segregated circumstances more than to the construction of more "white-like" homes to impress neighbors.

Being in proximity to Medford, Jacob's Chapel was the home congregation for the James Still family. Descendants of Levi and Charity Still, as well as several African American veterans of the Civil War, are buried in its cemetery. The cemetery holds the grave of James Still, brother of Peter and William.

Noted as the "Black Doctor of the Pines," James Still was a renowned healer. His son, James Jr., became the second black person to graduate from Harvard Medical School. His brother, William, became a leader of the Philadelphia Vigilance Committee and the Underground Railroad. His

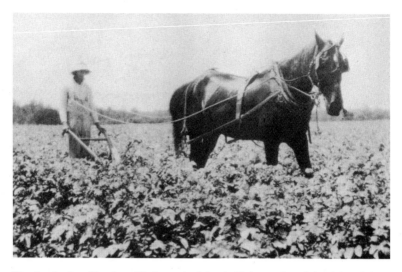

Plowing in the old style, with the mule doing half the work and the driver doing the rest. When hired out to clear a meadow or plow a field, this was the most common method employed through the late nineteenth century, when steam tractor power became more common. *In Norman Yetman,* Voices From Slavery, Yetman, *2000.*

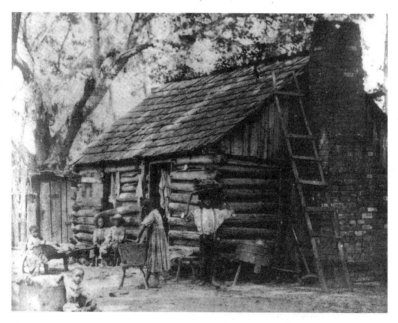

An example of the quarters to which Levi and Charity would have been accustomed in their pre-emancipation days. This style of construction appears to have remained consistent over time. It is found, with minor variations, throughout the small enclaves established in Southern New Jersey by free blacks and escaping slaves. *In Norman Yetman,* Voices From Slavery, *2000.*

parents, Levi and Charity (Cidney) Still, were slaves who initially brought two sons and two daughters with them to freedom.

The dates are approximate and the information scanty. Peter and Levin Still, their mother, Cidney, and two sisters (Kitturah and Mahalah) had escaped with their father, Levin Sr., and spent several months in Springtown, New Jersey. Recaptured from there, all but the father (Levin was a free black) were sent back to the plantation of a Mr. Griffin on the Eastern Shore of Maryland. A few months later, his mother escaped again, taking the girls with her. Being unable to take all the children, and possibly believing the boys would survive better than the girls until she could return for them, she made her way to Indian Mills in New Jersey to rejoin her husband. Very shortly after the above event, Peter and Levin were either "sold south" or stolen from Griffin.

Whether sold in retaliation for the escape of their mother, as Dennis Fradin indicates, or kidnapped from her prior to her escape, as Kate Pickard intimates, is not clear. Ernest Lyght adheres to the "sold South in retaliation" theory. Either way, it was a traumatic event.

A kidnapping of the boys prior to her leaving would correspond to our present sensibilities as to why a mother would leave her children behind. But, as Fradin's story tell us, Cidney believed she could not manage more than the two children and be successful in her trip, and she was afraid the boys would have her destination beaten out of them if she informed them of the plans in advance. So she took what might be called "Sophie's Choice," to apply a modern book theme, and left them. In any event, Cidney (now Charity) rejoined Levin, who had moved to Medford after the capture of his family, instead of going back to Springtown.

James and his ten siblings were born in the Medford area. In his adult life, he lived there and worshipped at the small church at Elbo Lane. Though he became well rounded and well read, his education was typical of the period.

For most of the late seventeenth and early eighteenth centuries, schooling was a luxury, not a necessity. Education at this time was still the responsibility of parents, relatives, one's self and the church. Very few people could afford to send their children to European schools, or even the newly developed centers of learning in Philadelphia. Of course, schools tended to be either for boys or for girls, since everyone knew that the required skills for each were distinctly different. Most learning was accomplished in the manner described years later by then-doctor James Still:

> *I was about eight or nine years old when I was first sent to school, and this was a new era to me. We went to school only in the bad weather and*

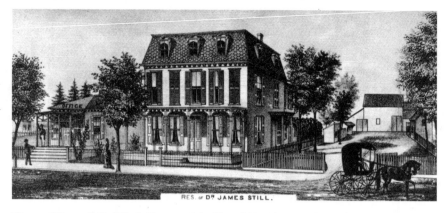

RES. of Dᴿ JAMES STILL.

Home of James Still, "Black Doctor of the Pines." To this home in Medford, New Jersey, came Peter Still to meet his long-lost brothers and sisters after being forty years in captivity. It represents a solidly middle-class residence of the mid- to late nineteenth century. *In E.S. Lyght, Path of Freedom, 1978.*

worked during the fair weather. Our school books were the New Testament and Comly's Spelling Book, in which we learned everything that was useful for man to know. The teacher taught us grammar in those books, and taught us how to pronounce everything improperly, and we knew no better.[139]

In contemplating American history, we often admire the self-taught backwoodsman, like Abe Lincoln, but forget that his was a typical mode of learning for much of the population until relatively recent times. Private schools were the only choice for most people who had money, with general schooling not arriving until the mid-nineteenth century.

Though mostly self-taught and using homemade remedies and potions, James was often sought out when traditional physicians were unable to solve a case. He was usually successful, leading to a well-established and lucrative career and a genteel lifestyle in Medford.[140]

James wrote an interesting and telling autobiography. In it, he talks about how his father, Levin, never spared the rod to spoil the child. Levin was relentless in demanding that the children work hard and earn their own way, never beholding to another. It is no wonder, considering Levin's experience with slavery, that he wanted his children to become free of economic chains, as well as legal ones.

The Still family continues to hold reunions and gatherings celebrating the nearly two hundred years of heritage since Levi and Charity slipped out to freedom. They currently have an organization in the Philadelphia area called, aptly, Still Connected.[141]

Chapter 12
Timbuctoo

An old West African proverb states: "Salt comes from the north, gold from the south, and silver from the country of the white men, but the word of God and the treasures of wisdom are only to be found in Timbuktu."[142]

Timbuktu is an African city in Mali, West Africa, and has always evoked mystery. At its peak in the sixteenth century, it boasted a university with a large library and twenty-five thousand students. Modern Timbuktu is a city in the Tombouctou Region. It is home to the prestigious Sankore University and other *madrasas* (schools), and it was an intellectual and spiritual capital and center for the propagation of Islam throughout Africa in the fifteenth and sixteenth centuries.[143]

Also known as Sankore Masjid, the University of Timbuktu is one of three ancient centers of learning there. During the fourteenth through the sixteenth centuries, Sankore University enrolled more foreign students than New York University does today.

Certainly, Western European intellectuals and traders were familiar with this African city by the late eighteenth century. Americans (especially academics) would have known of the city from the various books written about it in Europe. The general public would also have had tales of American sailors and stories related to them as a result of the interdiction of shipping by the Barbary pirates during the presidency of Thomas Jefferson.

Detailed Western knowledge of Timbuktu came from published notes and tales by students, merchants and travelers to the region. Shabeni was a merchant from Tetuan (a city in northern Morocco) who was captured and ended up in England. There, he told his story of how, as a child of fourteen in 1787, he had gone with his father to Timbuktu. A version of his story is related by James Grey Jackson in his book, *An Account of Timbuctoo and Hausa, 1820*:

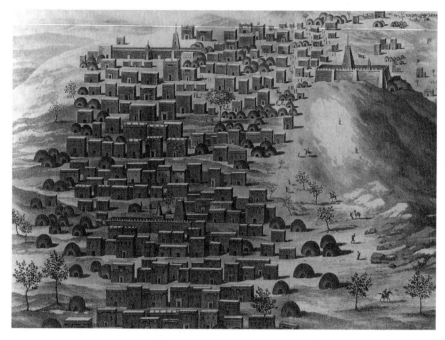

"Timbuctoo, the Mysterious." The African city shown in an early illustration by René-Auguste Caillié. *From J.O. and L.E Horton,* In Hope of Liberty, *1997.*

> *Timbuctoo is the great emporium for all the country of the blacks, and even for Morocco and Alexandria. The principal articles of merchandise are tobacco, kameemas [linen], beads of all colours for necklaces, and cowries, which are bought at Fas [Fez] by the pound. Small Dutch looking glasses, some of which are convex, are set in gilt paper frames.*[144]

General awareness of the city and its role in trade had been publicized for centuries, and so the name, at least, and its history as an "African Kingdom led by a black sultan," would have been familiar. In addition, the African city was known to have a population of Moors (interracial Spaniards) and to support a large and varied population from around the Mediterranean. Thus, the name "Timbuctoo" was also an apt reference to a community in New Jersey that hosted a variety of peoples. According to Ernest Lyght:

> *Timbuctoo, Westampton Township, is a small settlement located about two miles south of Mount Holly on the road from Rancocas to Mount Holly. It has always been a black community from its inception in the years 1820–25. The name Timbuctoo is African in origin. Local residents and maps have shortened it to Bucto.*[145]

Timbuctoo

The initial date of founding noted by Lyght indicates the name could have been in place from the start. People in New Jersey, as of the mid-1820s, would have been aware of the African city of the same name. It was in 1828 that the first European, René-Auguste Caillié, visited African Timbuktu and returned to tell the tale in three volumes published in 1830.[146] This publication date would indicate that "Timbuctoo" could easily have been the early name of the enclave near Mount Holly and not a later add-on.

Indication in slave narratives and Underground Railroad route maps of people seeking a haven at Mount Holly most likely referred to the general geographical area, also including the small enclave known as Timbuctoo and the colored community in the surrounding farmland. Timbuctoo is only two miles from the center of Mount Holly, an easy distance to cover, even on foot. Lyght writes:

> *Community focal points were the school house, the African Methodist Episcopal Zion Church, and the camp meeting grounds. The occasional erection of a new building usually created considerable sensation among residents.*

A swampy area in Timbuctoo similar to that pervasive throughout this section of the Rancocas Creek. Difficult to maneuver through unless you know where the high ground is, this is good hiding ground, but not so good farming ground. *Author's photo.*

Then, as now, the community was surrounded by woods, the permanent population never large. Fluctuations in population occurred as escaped or freed slaves entered the community and residents left to seek shelter, sanctuary or work farther away. The indication of its existence as of 1824 is found in a *New Jersey Mirror* obituary from February 27 of that year:

> *In Timbuctoo, near Mount Holly, on Friday last, HEZEKIAH HALL, (colored) aged about 60 years. The deceased, in early life, was a slave, and belonged to Charles Carroll, of Carrollton. He escaped from bondage in the year 1814. He settled in our midst about the year 1824, since which time he has resided here. He was regarded by every one [sic] as a man of unblemished character, and his truly upright walk and Christian deportment commanded the highest respect. His remains were followed to the grave on Sunday last by a very large concourse of friends and neighbors.*

The initial AME church in Mount Holly was Mount Moriah (Washington Street), which remains today. The population of Timbuctoo who belonged

Mount Moriah AME—Mount Holly. The original building was destroyed by a tornado. In 1863, this replacement was built on Washington Street, Mount Holly. *Author's photo.*

to this congregation would have walked the two miles or more to the church from their farms and homes for services. A church for the community was constructed on a slight hill on what is now Church Street. This comes off of Rancocas Road in Westampton Township. A second road, Blue Bird Lane, is another entrance to the principal geographic area of Timbuctoo. The only remaining indication of the community is the small cemetery, in which can be found the graves of several black Civil War veterans.

Stories abound locally in Mount Holly about the activity at Timbuctoo, yet little or no written information is available about the town. Perhaps this is in keeping with the tradition of "less is more" and with an oral tradition of historical record among the population. As with the stories related by Bessie Andrews about Springtown, most residents did not know, or refused to admit to, details of their previous lives—the threat of capture, kidnapping and enslavement was too real.

A PROTECTIVE ENCLAVE

As Giles Wright states, life as a black person in New Jersey was dangerous and uncertain.[147] As with any population, at any time, people generally gathered together to achieve mutual aid and support. It should be of no surprise that slave catchers and kidnappers would meet group resistance. The September 10, 1850 issue of the *New Jersey Mirror* noted:

> *The passage of the fugitive slave law and the results attending it, has caused the most intense excitement among the numerous colored persons residing in the vicinity of Mount Holly. We do not wonder that this should be the case. Those residing at the settlements around us have held many consultations and we are quite sure that any person going among them for the purpose of making an arrest would meet with a reception that would not be at all agreeable.*

The following article appeared in the *Mirror* only two months later on November 21, 1850:

> *At the colored church in Burlington (Bethlehem A.M.E.), on Sunday evening week, a number of negroes, suspecting a black man in the crowd to be acting as a spy for slave holders, made an attack on him. He was badly stabbed, and, escaping from the church, took refuge in a carpenter's shop, into which he got by breaking a window. He here defended himself with an axe. The blacks*

Timbuctoo Cemetery, 2008. The graves remaining are those of veterans of the United States Colored Troops who fought in the Civil War and hailed from, or came to live in, Timbuctoo. Restoration of the area and archaeological work is being planned. *Author's photo.*

everywhere are very much alarmed in reference to the provisions of the fugitive slave law, and it is not at all surprising that they should be excited in the highest degree when they have suspicions that a spy is hovering around their camp. But we think their better policy would be to remain as quiet as possible.[148]

Abductions and wrongful captures continued, despite the efforts of local free blacks to stem the tide. Current concern about child abduction is nothing new. The *New Jersey Mirror* of March 6, 1856, contained the story of a young boy by the name of Anderson, who lived with his free family. He was befriended by a man from Hainesport, who promised him work at his father's milk business in West Philadelphia. The boy and man negotiated terms, Anderson agreed to the employment and he went with the man to Philadelphia. But they continued to Baltimore, where the man attempted to sell the boy for $500. The boy ran to the Quakers there, telling them he was not a slave but had been taken from his family in Mount Holly. The phony slave owner was arrested and imprisoned. The Friends took care of the boy and returned him to his parents.[149]

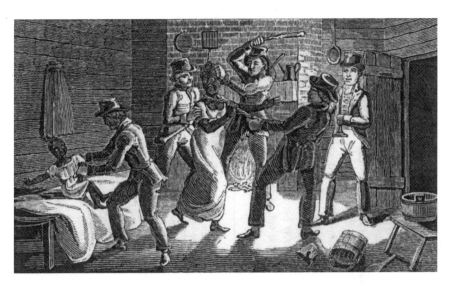

Kidnapping. Anywhere, anytime, you could become the next victim of the slave catcher or dishonest purveyor of souls. *New York Public Library Collection.*

A major thoroughfare up until the 1940s, the creek was well traveled by merchants and others on their way to or from Philadelphia and other ports, even after the railroad came through town. Along with these ships and barges came porters, stevedores, stowaways and deckhands. As noted previously, deckhand and stevedore were two occupations that seemed to have been allowed for free blacks. As a result, traveling through slave and free territory was easier for those in this employ than those traveling alone.

That Timbuctoo, like many of the other small towns that served as havens, is located a skip and jump from what were major shipping centers is probably not an accident. Ease of travel and concealment in the riverbank were essential to escaped slaves making their way to free areas. As noted in at least one instance in Timbuctoo, an escaped slave hid out in the swamps and tributaries of the creek for several days in inclement weather to escape the notorious George Alberti Jr.

News of the impending approach of slave catchers caused great alarm and defensive preparation among the residents and their supporters. Incidents can be gleaned from looking at newspaper reports. Of particular dread was Alberti, of Philadelphia, who made a career of the capture of escaped slaves throughout Southern New Jersey. His operations were in place at least from the passage of the Fugitive Slave Act to the Civil War. Alberti was the leader of the ad hoc posse that resulted in the Battle of the Swamp, in Timbuctoo, in 1860.

The *Mount Holly Herald,* in the fall of 1847, reported:

> *Considerable excitement was created in our community on Wednesday last in consequence of the arrest of three colored persons residing at Timbuctoo, named Commodore Chase, Aaron Chase, and Elizabeth Brooks (brothers and sister) by a person from Cecil County Maryland, who claims them as his slaves.*[150]

The three were brought before Judge Haywood at Mount Holly, and a jury returned a verdict in favor of the claimant. There was a large crowd of black citizens from Timbuctoo attending and milling around the courthouse throughout the day. The three captives "rushed upon the crowd and attempted to escape." The judge called on the local militia guard, who provided security and assistance to the sheriff in moving the prisoners through the crowd to the jail and patrolled the streets throughout the night. The opinion of the press was that the sheriff and the others had done their duties well.[151]

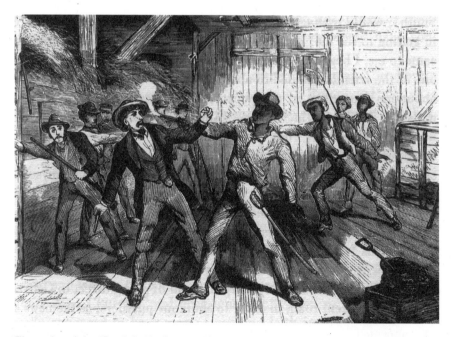

Illustrative of the "Battle in the Swamp," in your own community you could fight back. There was no *America's Most Wanted* in those days to obtain justice, only the vigilance committees and the support of free communities. *Illustration from William Still's* History of the Underground Railroad.

Reference to the Battle of the Swamp is a tradition in the Mount Holly area. From the appearance of the terrain surrounding the community (see accompanying illustration), it is evident that the "swamp" was the area between the village and Rancocas Creek. The creek winds through what is now Westampton Township from Mount Holly and east, on its way to the Delaware River.

The Battle in the Swamp took place near Timbuctoo in December 1860. The raiding party consisted of Alberti, a black former resident, Caleb Wright, and six to eight others coming from Philadelphia via Camden. Ernest Lyght relates how the target, Perry Simmons, had been living in the community for ten to twelve years at that point and was residing in a tenant house on the farm of one Allen Fennimore.[152] Perry was relatively well respected in the area and lived with his wife, seventeen-year-old son, twenty-one-year-old daughter and two small children.[153]

Local residents took up arms to repel him, and several people were injured. Not much is known about this engagement as yet, but Mr. Simmons was never captured.[154]

The February 13, 1862 *New Jersey Mirror* reported:

> *Perry Simmons, the colored man, whose attempted arrest as a fugitive slave, on two occasions, created considerable excitement in our neighborhood, died in Timbuctoo, a week or two ago. Perry had not been well since the last attempt to capture him, in consequence of taking a severe cold on that freezing night. It will be recollected that he was forced to fly suddenly from his bedroom to the garret, where he was obliged to remain till morning, suffering severely from the cold. Perry is at last beyond the reach of his Southern master.*

All of this said, the work of the Underground Railroad was rightly covert in a state where an elected senator claimed that the difficulty in the state was "not about surrendering fugitive slaves to their legal masters but rather how to get rid of those worthless slaves which the South suffer to escape into our territory, and remain there to the annoyance of our people."[155] Tensions between blacks and whites were palpable, even in a "tolerant" community in the "free" North.

Timbuctoo is noted often in local histories as the site of "camp meetings" during the nineteenth and early twentieth centuries.[156] Many older residents recall the noisy and boisterous crowds of blacks and whites gathering to hear the preachers and singing. These meetings would often last for days, with folks setting up camp nearby or living with relatives and friends (hence the

term "camp" meeting). The rich heritage is seen today in the broad appeal of Mount Moriah Church, and other congregations in the area, and the many services and supports provided to members and nonmembers alike. Occasionally, there are still camp meetings held down at Church Lane.

Near Burlington, New Jersey, about 1852

*E*arly *the next morning, Dr. James Still, with his new found brother, and the two sisters set out to visit their mother, who lived eight miles distant. On the way they agreed, as far as possible, to avoid surprising or exciting their mother, as on account of her great age (she was nearly eighty) they feared that by a shock, even though it were a joyful one, she might be overcome.*

The venerable woman lived with Samuel, the oldest, except Peter, of her sons, upon the farm which had been owned by her late husband. When her children, arrived, she had just risen, and was standing in the door. Peter's first impulse was to spring from the wagon, and to clasp the precious form of his mother to his heart, but his sisters' caution sounded in his ears, and he struggled to control himself. Forcing back the flood of tenderness which came gushing up from his throbbing heart, he walked with placid face behind his sisters, who advanced to greet their beloved parent.

Peter soon discovered that the habits and condition of his relatives differed widely from those described in the South as universal among "free negroes." They were all industrious and frugal; and consequently, in comfortable circumstances. He did not envy them, but, as he noticed their intelligence, and saw the comforts by which they were surrounded in their own homes, he could not avoid the thought that slavery had kept him ignorant and poor. "But times will change," thought he, "and if ever I get my family, my children shall have a chance to know as much as others."

Peter chose a seat near his mother, and subduing his emotions, gazed earnestly upon her aged face. There was the same mole concerning which he had so often disputed with his brother Levin, who always maintained that it was only a dark spot upon her face. His thoughts were busy with the past. Ah! how well he remembered the time when his young lips had pressed that mother's cheek, when all his childish grief had been forgotten while he lay folded to that loving breast.

He remembered too, the kidnapper, with his slimy, lying tongue; his transfer to Kentucky, and the heavy blows by which they strove to crush out from his young heart the memory of his mother's love, all his long years of weary, unrequited toil—a sad procession, passed before him as he sat apparently a calm spectator of the joyous greetings of his kindred. His brother also, he remembered, and that brother's grave, a far-off, unmarked grave, and all that brother's sorrows. Yes, he remembered all the past. The host of cruel wrongs which he had suffered rushed at once into his mind, and from the stand point which he had now gained, the heartless acts of his oppressors, looked a hundred fold more hateful than before.

But he was not long left to his own thoughts. The excitement of their arrival having subsided, he said to his mother, "Are all these your children."

"Yes," she replied, "the most of them are mine."

"You have a large family."

"Yes, I have had eighteen children."

"How many have you livin'?"

"I have buried eight, and I have eight, living."

"I thought you said you had eighteen—eight livin' and eight dead would make but sixteen."

The breast of the aged woman heaved as with long-pent anguish! "Ah!" said she, "them two boys have been more trouble to me than all the rest of my children. I've grieved about them a great many years."

"What became of them?" asked Peter.

"I never knew what became of them. I left them asleep in the bed, the last time I ever see them. I never knew whether they was stole and carried off, or whether they was dead. I hope though, they're in heaven."

One of the other sisters then approached the mother, and broke to her the joyful news. The aged woman sat for a moment bewildered by the strange scene—then rising, she walked into the next room, where she knelt in prayer.

In a short time she returned, trembling in every limb, though her face was calm. "Who are you?" said she, approaching the stranger.

"My name," said he, "is Peter, and I had a brother Levin. My father's name was Levin, and my mother's name was Sidney—"

The mother raised her tear-dimmed eyes to heaven. "O, Lord," she cried, "how long have I prayed to see my two sons! Can it be that they have come? Oh! if you are my child, tell me how d'y' once more!"

The long-lost son was blest. He, clasped his mother to his warm, full heart, and joyful tears stole down his dusky cheeks.[157]

—*Kate Pickard, 1856*

Notes

PROLOGUE

1. Pickard, *Kidnapped and the Ransomed*; and Fradin, *My Family Shall Be Free!*

CHAPTER 1

2. Ward, *North American Slave Narratives.*
3. http://www.digitalhistory.uh.edu/black_voices/black_voices.cfm.
4. Steward, *Colored Regulars*, 23.
5. Reed, *Platform for Change*; and Horton and Horton, *Slavery.*
6. Eliot, *Autobiography of Benjamin Franklin.*
7. Heite, L. "Delaware's Invisible Indians."
8. Switala, *Underground Railroad.*
9. Steward, *Colored Regulars*, 25.
10. Ibid.
11. Norwood, *We Are Still Here.*
12. West Jersey Project, Court Records, www.westjerseyhistory.org/docs/gloucesterrecs/slavery/.
13. Koedel, *South Jersey Heritage.*
14. Ibid.
15. Ibid.
16. Reed, *Platform for Change.*
17. Price, *Freedom Not Far Distant.*
18. For example, praise and letters about life in Canada abound in William Still's narrative on the Underground Railroad and the Philadelphia Vigilance Society, and in individual slave narratives and stories.
19. Hooks, *Killing Rage.*

CHAPTER 2

20. Most of the material in this section comes from Acrelius, "Swedes and Dutch"; Carpenter and Arthur, *History of New Jersey*; Koedel, *South Jersey Heritage*; and Mulford, *Civil and Political History.*
21. Acrelius, "Swedes and Dutch."
22. Ibid.
23. Woodward and Hageman, *History of Burlington and Mercer Counties.*
24. About New Jersey, "Pennsville—New Sweden Days," www.aboutnewjersey.com/News/newSwedenHeritageDays_6_2_04.php.

CHAPTER 3

25. Chief Roy Crazy Horse, http://www.powhatan.org/history.html.
26. Rizzo, *Mount Holly.*
27. Ibid.
28. Os Cresson, "In Their Footsteps," 2005. A brief history of the lives of people who lived on the property called Lumberton Leas, at http://www.mlra.org/footsteps/index.htm#one.
29. Norwood, *We Are Still Here.*
30. History of Swedesboro, http://nj.searchroots.com/Gloucesterco/swedesborohistory.htm.
31. Norwood, *We Are Still Here.*
32. Heite, L., "Delaware's Invisible Indians."
33. Flemming, *Brotherton.*
34. Erickson, *Native American Drum Beat*, 11.
35. Pennsylvania Department of Tourism, Explore PA History, 2008, "Historic Markers: Tinicum," www.explorepahistory.*com/hmarker. php?markerId=48.*
36. Koedel, *South Jersey Heritage.*
37. Ibid.
38. Ibid.
39. Jaquett and VanName, *Place Names.*
40. Koedel, *South Jersey Heritage.*
41. Flemming, *Brotherton.*
42. Heite, E., "Delaware's Invisible Indians"; and Turk, interview.

Chapter 4

43. Steward and Steward, *Gouldtown.*
44. Cole, *History of Fairfield Township.*
45. Kolkoff, "Fugitive Communities."
46. Steward and Steward, *Gouldtown.*
47. Ibid.
48. Cole, *History of Fairfield Township.*
49. Dyson, "Review of Gouldtown."
50. Ibid
51. Cole, *History of Fairfield Township.*
52. Steward and Steward, *Gouldtown.*
53. Ibid.
54. Ibid.

Chapter 5

55. Wikipedia, s.v. "Anthony Benezet," http://en.wikipedia.org/wiki/Anthony_Benezet.
56. Switala, *Underground Railroad*, 35–36.
57. Davis, *Problem of Slavery.*
58. Eliot, *Autobiography of Benjamin Franklin.*
59. Burlington County Historical Society, http://www.burlco.lib.nj.us/county/history/memorable.html.
60. George Washington Papers, http://etext.virginia.edu.
61. Eliot, *Autobiography of Benjamin Franklin.*
62. Wright, *Afro-Americans in New Jersey.*
63. Ibid.
64. Switala, *Underground Railroad.*
65. Wright and Wonkerer, *Steal Away.*
66. Switala, *Underground Railraod.*
67. George Washington to Robert Morris, letter, April 12, 1786, Library of Congress.
68. http://www.petermotthouse.org/news/UGRRBook.html.
69. Switala, *Underground Railroad.*
70. Quaker Writings, http://www.qhpress.org/quakerpages/qwhp/qwhp.htm.
71. Public Broadcasting System, 2006, "Africans in America Resource Bank," www.pbs.org/wgbh/aia/part3/.

72. Ibid.
73. Grandy, "Narrative."
74. Still, *Underground Railroad.*
75. Horton, "Flight to Freedom."
76. United States National Park Service, "Aboard the Underground Railroad."
77. Switala, *Underground Railroad.*
78. Siebert, *Underground Railroad.*
79. Wright and Wonkerer, *Steal Away.*
80. Larson, *Bound for the Promised Land.*
81. Ibid.
82. Ibid.
83. Ibid.
84. Trusty, *Underground Railroad,* 203.
85. Ibid.
86. Wright and Wonkerer, *Steal Away.*
87. United States National Park Service, www.bulls-eyepro.com/abolition.htm.

CHAPTER 6

88. Ward, *North American Slave Narratives.*
89. National Park Service, "Salt Hay Harvest, Past and Present," www.nps.gov/history/history/online_books/nj3/chap5.htm.
90. Switala, *Underground Railroad.*
91. New Jersey Writer's Guild, *New Jersey.*
92. Ward, *North American Slave Narratives.*
93. Bordewich, *Bound for Canaan.*
94. Andrews, *Reminiscences of Greenwich.*
95. Trusty, *Underground Railroad.*
96. Boynton, "Springtown New Jersey."
97. Ibid.
98. Ibid.
99. Trusty, *Underground Railroad,* 159.
100. Larson, *Bound for the Promised Land.*
101. Bryant, "Personal Notebook."
102. Andrews, *Reminiscences of Greenwich.*
103. Ibid.

CHAPTER 7

104. Turk, interview.
105. African Union Methodist Protestant Church, "Our History."
106. Russell, *History*.
107. Ward, *North American Slave Narratives*.

CHAPTER 8

108. Drew, *North-Side View*.
109. Cohen, *Folk Legacies Revisited*, 37.
110. Ibid., 36.
111. Price, *Freedom Not Far Distant*.
112. Yetman, *Voices From Slavery*.
113. John Watson, "Farm Life: Life Growing Up On A Texas Farm," http://members.tripod.com/buckcreek/book.html.
114. National Park Service, "Aboard the Underground Railroad."

CHAPTER 9

115. "Historic Croft Farm," www.cherryhill-nj.com/government/departments/recreation/croft.asp.
116. Ibid.
117. Still, *Underground Railroad*.
118. Ward, *North American Slave Narratives*.
119. Moore, *Grandfather's Farm*.
120. Saddler's Woods Conservation Association, Oaklyn, New Jersey, http://www.saddlerswoods.org/.

CHAPTER 10

121. Lee, *Religious Experience*.
122. Schopp, interview.
123. Smiley, *True Story of Lawnside*.
124. Ibid.
125. Speights, *Mt. Pisgah A.M.E. Church*.
126. Schopp, interview.

127. Smiley, *True Story of Lawnside.*
128. Ibid.
129. Speights, *Mt. Pisgah A.M.E. Church.*
130. Benson, *Pisgah Historical Notes.*
131. Lee, *Religious Experience.*
132. Lowry, *Harriet Tubman.*

CHAPTER 11

133. Drew, *North-Side View.*
134. Trusty, *Underground Railroad.*
135. Schopp, interview.
136. "Historic Croft Farm."
137. Lyght, *Path of Freedom.*
138. Drew, *North-Side View.*
139. Still, *Early Recollections.*
140. Ibid.
141. Still Connected, the William Still Underground Railroad Foundation, Inc., http://www.undergroundrr.com/.

CHAPTER 12

142. International Museum of Muslim Culture, Sankore University, www.muslimmuseum.org/SankoreUniversity.aspx.
143. The 153 Club, "Timbuctoo the Mysterious."
144. Ibid., "Shabeni's Description of Timbuktu."
145. Lyght, *Path of Freedom.*
146. The 153 Club, "Timbuctoo the Mysterious."
147. Wright and Wonkeror, *Steal Away.*
148. Rizzo, *Mount Holly.*
149. Wright, *Afro-Americans in New Jersey.*
150. *Mount Holly Herald*, 1847 Article referenced in Joseph C. Cowgill, "Personal Scrap Book," Mount Holly Historical Society Collection, J.C. Cowgill Collection.
151. Rizzo, *Mount Holly.*
152. Lyght, *Path of Freedom.*
153. Ibid.
154. Shinn, *History of Mount Holly.*

155. Wright, *Afro-Americans in New Jersey.*
156. Lyght, *Path of Freedom.*

EPILOGUE

157. Pickard, *Kidnapped and the Ransomed*; and Fradin, *My Family Shall be Free!*

Bibliography

Acrelius, Israel. "The Swedes and Dutch in New Jersey and Delaware." In *Great Epochs in American History, Vol. II, The Planting of the First Colonies: 1562–1733*, edited by F. Halsey. New York: Current Literature Publishing Company, Funk & Wagnells, 1916.

Allen, Richard. *The Life, Experience and Gospel Labours of the Rt. Rev. Richard Allen*. Philadelphia: Martin and Boden, 1834.

Andrews, Bessie A. *Reminiscences of Greenwich*. Vineland, NJ: printed for the author, G.E. Smith, 1910. Reprint, Cumberland County Historical Society, 1962.

Bailey, Shirley R., ed. *Yesteryear on the Maurice River*. Millville, NJ: South Jersey Publishing Company, 1977.

Bayley, Solomon. *A Narrative of Some Remarkable Incidents in the Life of Solomon Bayley, Formerly a Slave in the State of Delaware, North America; Written by Himself*. London: Harvey and Darton, 1825.

Beck, Henry.C., ed. *Forgotten Towns of Southern New Jersey*. New Brunswick, NJ: Rutgers University Press, 1983.

Benson, Reverend James. *Pisgah Historical Notes*. Lawnside, NJ: Mount Pisgah Church, 2005.

Bisbee, Henry H. *Place Names in Burlington County*. Riverside, NJ: Burlington County Publishing Company, 1955.

Blockson, Charles L. *The Underground Railroad: First Person Narratives of Escapes to Freedom in the North*. New York: Prentice Hall Press, 1987.

Boen, William. *Anecdotes and Memoirs of William Boen, a Coloured Man, Who Lived and Died Near Mount Holly, New Jersey*. Philadelphia: John Richards, 1834.

Bordewich, Fergus M. *Bound for Canaan: The Underground Railroad and the War for the Soul of America*. New York: Harper Collins, 2005.

Bowen, F.W. *History of Port Elizabeth, Cumberland County, NJ.* Philadelphia: L.B. Lippincott Company, 1885.

Boynton, Maria. "Springtown New Jersey: Explorations in the History and Culture of a Black Rural Community." PhD diss., University of Pennsylvania, 1994.

Brainerd, John. *John Brainerd's Journal.* Works Progress Administration, Historical Records Survey, 1941.

Bryant, Louisa. "Personal Notebook." 1960. Bryant family collection. Springtown, New Jersey.

Carpenter, W.H., and T.H. Arthur. *History of New Jersey from its Earliest Days to the Present Time.* Philadelphia: J.D. Lippincott, 1856.

Cohen, David S. *Folk Legacies Revisited.* New Brunswick, NJ: Rutgers University Press, 1995.

Cole, George M. *The History of Fairfield Township, Cumberland County Historical Society.* Greenwich, NJ: Fairfield Township Tri-Centennial Committee, 2007.

Condeluci, Anthony. "Community and Social Capital." In *Cultural Shifting.* St. Augustine, FL: TRN Press, 2002.

Cumberland County Historical Society. "Census of 1850: Springtown, NJ." Copy of U.S. Census data. Cumberland County Historical Society, Greenwich, New Jersey.

———. "Slaves in Cumberland County, NJ." Transcription of County Records of Slave Manumissions. Cumberland County Historical Society, Greenwich, New Jersey.

Davis, David Brion. *The Problem of Slavery in Western Cultures.* New York: Oxford University Press, 1966.

De Tocqueville, Alexis. *Democracy in America.* Edited by J.P. Mayer. New York: Harper Perennial, 1988.

Dorwart, Jeffrey M. *Camden County, New Jersey: The Making of a Metropolitan Community, 1626–2000.* New Brunswick, NJ: Rutgers University Press, 2000.

Drew, Benjamin. *A North-Side View of Slavery.* Boston: J.P. Jewett and Company, 1856. Available at the "Documenting the American South" website, University of North Carolina at Chapel Hill, www.docsouth.unc.edu.

Dyson, Walter. "Review of Gouldtown, by Steward and Steward." *Journal of Negro History* 1 (January 1916).

Eliot, C.W., ed. *The Autobiography of Benjamin Franklin. The Journal of John Woolman. Fruits of solitude/William Penn; with introductions and notes.* Harvard Classics, Vol. 1. New York: P.F. Collier, 1909.

Erickson, L. *Native American Drum Beat, in South Jersey Traditions.* Down Jersey Folk Life Center, 2007. Available at www.wheatonarts.org/downjersey/aboutdjflc/newsletters/Newsletter_Spring2007.pdf.

Fisher, Sydney G. *The Quaker Colonies, a Chronicle of the Proprietors of the Delaware.* New Haven, CT: Yale University Press, 1991.

Fishman, G. *The African American Struggle for Freedom and Equality.* New York: Garland Publishing, 1997.

Flemming, George. *Brotherton—New Jersey's First and Only Indian Reservation and the Communities of Shamong and Tabernacle That Followed.* Medford, NJ: Plexus Publishing, 2005.

Fradin, Dennis B. *My family shall be free!: the life of Peter Still.* New York: HarperCollins, 2001.

Frost, Karolyn Smardz. *I've Got a Home in Glory Land.* New York: Farrar, Strauss and Giroux, 2007.

Gordon, T.F. *A Gazetteer of the State of New Jersey.* Trenton, NJ: Daniel Fenton, Publisher, 1834.

Grandy, Moses. "Narrative of the Life of Moses Grandy; Late a Slave in the United States of America, C. Gilpin, 5, Bishopsgate-street London." 1843. Available at the "Documenting the American South" website, University of North Carolina at Chapel Hill, www.docsouth. unc.edu.

Harrison, C. *Salem County: A Story of People.* Norfolk/Virginia Beach, VA: The Donning Company, n.d.

Historical Society of Haddonfield. "This is Haddonfield." Camden County Library Collection, 1963.

Hooks, Bell. *Killing Rage: Ending Racism.* New York: Henry Holt and Company, 1995.

Horton, James Oliver. "Flight to Freedom: One Family and the Story of the Underground Railroad." *OAH Magazine of History* 15, no. 4 (Summer 2001).

Horton, James Oliver, and Lois E. Horton. *In Hope of Liberty: Culture, Community and Protest Among Northern Free Blacks.* New York: Oxford University Press, 1997.

———. *Slavery and the Making of America.* New York: Oxford University Press, 2005.

Jaquett, Josephine, and Elmer VanName. *Place Names of Salem County N.J, West Jersey Project.* Salem County Historical Society, 2007.

Johnson, C., and P. Smith. *Africans in America: America's Journey Through Slavery.* New York: Harcourt, Inc., 1998.

Kalm, Peter. *The America of 1750: Peter Kalm's Travels in North America ("The English Version of 1770").* Translated and edited by Adolph B. Benson. New Haven, CT: Yale University Press 1937. Reprint, Dover Publications, 1966.

King, Charlotte. "Passed by Time: America's All-Black Towns." Honors thesis, Department of Anthropology, University of Maryland, 2003.

Koedel, R. Craig. *South Jersey Heritage: A Social, Economic and Cultural History.* Washington, D.C.: University Press of America, Inc., 1979.

Kolkoff, M. "Fugitive Communities in Colonial America." *The Early American Review* 3, no. 4 (2001).

Larson, Kate Clifford. *Bound for the Promised Land—Harriet Tubman: Portrait of an American Hero.* New York: Ballentine Books, 2004.

Lee, Jarena. *Religious Experience and Journal of Mrs. Jarena Lee.* Philadelphia: self-published, 1836. Available at the "Documenting the American South" website, University of North Carolina at Chapel Hill, www.docsouth.unc.edu.

Litwack, L.F. *North of Slavery: The Negro in the Free States 1790–1860.* Chicago: University of Chicago Press, 1961.

Lowry, Beverly. *Harriet Tubman: Imagining a Life.* New York: Doubleday, 2007.

Lyght, Ernest S. *Path of Freedom: The Black Presence in New Jersey's Burlington County 1659–1900.* Cherry Hill, NJ: E&E Publishing House, 1978.

Mappen, Marc. "Jerseyana: Sylvia Dubois." *New York Times*, March 11, 1990.

McMahon, W. *More South Jersey Towns.* New Brunswick, NJ: Rutgers University Press, n.d.

———. *South Jersey Towns.* New Brunswick, NJ: Rutgers University Press, 1973.

Moore. M.P. *Grandfather's Farm: Life on the Cohansey Plantation of Squire Maskell Ewing.* Greenwich, NJ: Cumberland County Historical Society, 1981.

Morgan, J.H. *History of the New Jersey Conference, A.M.E. Church.* Camden, NJ: S. Chew, Printer, 1887.

Mulford, Isaac S. *Civil and Political History of New Jersey.* Philadelphia: C. A. Brown & Co., 1851.

New Jersey Writer's Guild. *New Jersey, A Guide to Its Present and Past.* New York: American Guide Series, Works Progress Administration, Hastings House, 1946.

New Jersey Writer's Project. *The Underground Railroad in New Jersey.* Newark, NJ: Works Projects Administration, 1940.

Norwood, J.R. *We Are Still Here: The Tribal Saga of New Jersey's Nanticoke and Lenape Indians.* Moorestown, NJ: Native New Jersey Publications, 2007.

Pickard, Kate. *The Kidnapped and the Ransomed: Being the Personal Recollections of Peter Still and his Wife "Vina" after Forty Years of Slavery.* 3rd edition. New York: Miller, Orton and Mulligan, 1856. Available at the "Documenting

the American South" website, University of North Carolina at Chapel Hill, www.docsouth.unc.edu.

Pomfret, John Edwin. *The Province of West Jersey: 1609–1702*. Princeton, NJ: Princeton University Press, 1956.

Price, Clement A. *Freedom Not Far Distant: A Documentary of Afro-Americans in New Jersey*. Newark, NJ: New Jersey Historical Society, 1980.

Rael, Patrick. *Black Identity and Black Protest in the Antebellum North*. Chapel Hill: University of North Carolina Press, 2002.

Raible, D.G. *Down a Country Lane*. Camden, NJ: Camden County Historical Society, 2000.

Reed, Harry. *Platform for Change: The Foundations of the Northern Free black Community, 1775–1865*. East Lansing: Michigan State University Press, 1994.

Rizzo, Dennis. *Mount Holly: A Hometown Reinvented*. Charleston, SC: The History Press, 2007.

Russell, Daniel J. *History of the African Union Methodist Protestant Church*. Philadelphia: Union Star Book and Job Printing and Publishing House, 1920. Available at the "Documenting the American South" website, University of North Carolina at Chapel Hill, www.docsouth.unc.edu.

Shinn, Henry. *The History of Mount Holly*. Burlington County College, 1957. Reprint, 1998.

Shrouds, Thomas. *History and Genealogy of Fenwick's Colony*. Bridgeton: George Nixon, 1876.

Sickler, Joseph S. *History of Salem County, New Jersey*. Salem, NJ: Sunbeam Publishing Co., 1937.

————. *Tea Burning Town: The Story of Greenwich on the Cohansey in West Jersey*. Bicentennial commemorative edition. Bridgeton, NJ: The Greenwich Press, 1950.

Siebert, Wilbur H. *The Underground Railroad: From Slavery to Freedom*. New York: Russell & Russell, 1898. Reprint, New York: Macmillan Co., 1967.

Smiley, Charles C. *True Story of Lawnside*. Camden, NJ: R.C. Wythe Jr., printer, 1921.

Solem-Stull, Barbara. *Ghost Towns and Other Quirky Places in the New Jersey Pine Barrens*. Medford, NJ: Plexus Publishing, 2005.

Speights, Reverend Harold P. *Mt. Pisgah A.M.E. Church: 188th Anniversary*. Lawnside, NJ: Mount Pisgah Church, 1980.

Steward, Theopholus Gould. *The Colored Regulars in the United States Army*. Humanity Books, Prometheus, 2003.

Steward, William, and Theopholus G. Steward. *Gouldtown, A Very Remarkable Settlement of Ancient Date*. Philadelphia: J.B. Lippincott Co., 1913.

Still, James. *Early Recollections and Life of Dr. James Still.* New Brunswick, NJ: Rutgers University Press, 1973.

Still, William. *The Underground Railroad.* Chicago: Johnson Publishing, 1871. Reprint, Ebony Classics Edition, 1970.

Stone, W. "The Life-Areas of Southern New Jersey." *Journal of the Proceedings of the Academy of Natural Sciences* 2, no. 1, j (1907).

Switala, William J. *Underground Railroad in New Jersey and New York.* Mechanicsburg, PA: Stackpole Books, 2006.

Tate, Gayle T. "Free Black Resistance in the Antebellum Era, 1830 to 1860." *Journal of Black Studies* 28, no. 6 (July 1998): 764–82.

Torrey, Jesse. *The American Slave Trade.* 1822. Reprint, Kessinger Publishing, n.d.

Trusty, Emma Marie. *The Underground Railroad—Ties that Bound Unveiled: A History of the Underground Railroad in Southern New Jersey from 1770 to 1861.* Philadelphia: Amed Literary, Inc., 1999.

Ward, Samuel R. *Autobiography of a Fugitive Negro.* 1855. Available at the "Documenting the American South" website, University of North Carolina at Chapel Hill, www.docsouth.unc.edu.

Wayman, Alexander W. *Cyclopedia of African Methodism.* Baltimore: Methodist Episcopal Book Depository, 1822.

Weiss, Harry Bischoff. *The Early Grist and Flouring Mills of New Jersey.* Trenton: New Jersey Agricultural Society, 1956.

Wood, William, et al. *Narratives of Colored Americans.* New York: printed by Order of the Trustees of the Residuary Estate of Lindley Murray by John F. Trow & Son, Printers and Bookbinders, 1875.

Woodward, E.M. and J.F. Hageman. *The History of Burlington & Mercer Counties—With Biographical Sketches of many of their Pioneers and Prominent Men.* Philadelphia: Everts & Peck, Press of JB Lippincott & Co, 1883.

Woolman, John. *A Word of Remembrance and Caution to the Rich.* Burlington, NJ: published by David Allinson, S.C. Ustick, printer, 1803.

Wright, Giles R. *Afro-Americans in New Jersey.* Trenton: New Jersey Historical Commission, 1988.

Wright, Giles R., and Edward Wonkerer. *Steal Away, Steal Way: A Guide to the Underground Railroad in New Jersey.* Trenton: New Jersey Historical Commission, 2006.

Wright, Robert. "Listing of Persons Buried in Ambury Hill Cemetery." Typewritten list, n.d. Cumberland County Historical Society, Greenwich, New Jersey.

Yetman, Norman R., ed. *Voices From Slavery.* Mineola, NY: Dover Publications, 2000.

INTERNET RESOURCES AND SITES

African Union Methodist Protestant Church. "Our History." www.aufcmp. org/history.htm.

Chief Roy Crazy Horse. Powhattan Renape Confederation Home Page. http://www.powhatan.org/history.html.

Cook, J.W. "Dancing across the Color Line." *Common-Place* 4, 1 (October 2003). www.common-place.org/vol-04/no-01/cook/index.shtml.

George Washington Papers. Electronic Text Center. University of Virginia Library. http://etext.virginia.edu.

Graff, S. "A Journey to Springtown." *Philadelphia City Paper*, November 11–18, 1999. http://www.citypaper.net.

Heite, Edward. "Delaware's Invisible Indians, part II." www.mitsawokett. com/HeiteReport1.htm#Delaware's.

Heite, Louise. "Delaware's Invisible Indians, part I." www.mitsawokett. com/HeiteReport1.htm#Delaware's.

National Park Service. "Salt Hay Harvest, Past and Present." www.nps.gov/ history/history/online_books/nj3/chap5.htm.

New Jersey State Library Digital Collections. "NJ African American History Curriculum (9–12)." www.njstatelib.org/NJ_Information/Digital_ Collections/AAHCG/unit8.html

The 153 Club. http://www.the153club.org/timbuctoo.html.

Quaker Writings. www.qhpress.org/quakerpages/qwhp/qwhp.htm.

Still Connected, the William Still Underground Railroad Foundation, Inc. http://www.undergroundrr.com/.

Swedish Colonial Society. http://www.colonialswedes.org/Churches/ TriEpi.html.

United States National Park Service. "Aboard the Underground Railroad— A National Registry Itinerary." www.nps.gov/history/nr/travel/ underground/ugrrhome.htm.

———. New Jersey Coastal Heritage Trail Route. www.nps.gov/history/ history/online_books/nj2/app2.htm.

U.S. Public Broadcasting System. "Africans in America Resource Bank." www.pbs.org/wgbh/aia/part3/.

West Jersey Project, 2008. www.westjerseyhistory.org.

INTERVIEWS AND CONVERSATIONS

Laura Aldrich, lifelong member, Springtown AME Church congregation. 2008. (Laura helped achieve National Register status for the building. She is also a descendant of the Bryants, founders of Othello and Springtown.)

Reverend James Benson, historian. Lawnside, New Jersey. 2008.

Chris Butler. Lawnside Historical Society, Lawnside, New Jersey. 2008.

Wilbert Green, descendant of the Bryants, founders of Othello and Springtown, New Jersey. 2008.

Paul W. Schopp, senior historian, DMJM. Harris, Trenton.

James Turk. Salem County Historical Commission, Salem, New Jersey.

Giles Wright, historian. New Jersey Historical Commission, Trenton.

MAPS, PHOTOGRAPHS AND ILLUSTRATIONS

Library of Congress Prints and Photographs collection. http://memory.loc.gov/cgi-bin.

New Jersey Historical Society Digital Collections. http://www.jerseyhistory.org/explorecoll.php.

New York Public Library Digital Collections. http://digitalgallery.nypl.org/nypldigital.

Pomfret, J.E. *The Province of West Jersey: 1609–1702*. Princeton, NJ: Princeton University Press, 1956.

Rutgers University Special Collections. Digitized maps of New Jersey. http://mapmaker.rutgers.edu/MAPS.html.

Seventeenth Century Shipping. www.wolfson.ox.ac.uk/~ben/shipimages.

Stewart, D.J. *Historical Atlas of Cumberland County*. Greenwich, NJ: Cumberland County Historical Society, 1876. Reprint, 2004.